OXFORDSHIRE
Place Names

OXFORDSHIRE
Place Names

ANTHONY POULTON-SMITH

AMBERLEY

First published 2009

Amberley Publishing
Cirencester Road, Chalford,
Stroud, Gloucestershire, GL6 8PE

www.amberley-books.com

British Library Cataloguing in Publication Data.
A catalogue record for this book is available from the British Library.

ISBN 978 1 84868 171 2

Typesetting and origination by Amberley Publishing
Printed in Great Britain

Contents

Introduction

When the Anglo-Saxons arrived in England in the fifth century they brought conflict, culture and a language which evolved to become the basis of modern English. Many of today's short, sharp words come directly from Old English and yet if you were to hear it spoken, even in its simplest form you would be hard pressed to understand a single word. Thankfully there are those who have studied and analysed the language which has produced many of the place names of England, and virtually all in Oxfordshire.

There are other languages which have provided some of the names of the county. The British tribes, here long before the arrival of the Romans, have provided the names for many of the nation's apparently permanent geographical features such as rivers and hills. Whilst we know little of the actual spoken tongue as it left no written records, it can often be interpreted by comparison with known languages which survive from that era such as Cornish, Welsh, Gaelic, and Breton. Many of these British names seem overly simplistic. Surely meanings such as 'water, flowing, stream, spring, hill, summit, ridge' can hardly be considered 'names' as they give no individuality which is the whole reason for the name in the first place. However even today the local river is rarely referred to by name when speaking to someone who also hails from that area, being known by the anglers as 'the river' or walkers and hikers speak of 'the hills'.

Incidentally, the Romans may have had great influences on the culture and technologies of Britain, however, their contribution to place names was neglible seemingly restricted to Magna and Parva (great and small), or by association with them. It was once thought that names ending in -cester or -chester came from Latin castra but, even though the meaning is effectively the same, the true origin is Old English ceaster or 'Roman stronghold'. Once regarded as conquerors of a gloomy island populated by barbaric peoples, recently thoughts have changed as to the Roman occupation when someone bothered to ask, if Britain was so bad, why the Empire ever bothered to come here. It now appears the British, with one or two notable exceptions, almost welcomed the new arrivals with open arms. Their technology and greatly improved standard of living could only have been a boon to the country, developing a distinct Romano-British culture. The expansion of the Roman Empire saw them assimilate many facets of the conquered

lands including technologies, territories, people and even gods. Indeed even the straight roads, which the Romans are so famous for, were probably already in existence prior to the founding of Rome around 753 BC.

Abandoning life as a hunter-gatherer, man settled down in his hill forts and began an agricultural way of life. Eventually their largely self-sufficient existence saw them reach out to trade with their neighbours and thereafter with settlements further afield. In order to find a certain product or a particular settlement, travellers would require directions. Given by neighbouring settlements these would be a description of the place, its location, its use, or its inhabitants. In time these descriptions would become place names.

Methods used to define a place name depends upon just what the 'place' in question is, be it a town, village, mountain, hill, stream, river, field, Roman road, modern street or public house. Yet with all these, apart from pub names which is a special case and will be dealt with separately, we need to find as many early forms as possible. Tracking these names means searching through a variety of ancient documents, including the first compilation of place names written by the Venerable Bede. However these are rarely the original copies of these documents, often just copies of copies of copiesn and the accuracy should always be questioned for as each copy is made the likelihood of errors becomes not only possible but probable as they are being copied because they are becoming illegible.

The question of accuracy is particularly relevant in the case of Domesday, but for different reasons. It was compiled by men who spoke Old French, based on a survey of those speaking a Germanic language, and transcribed in a form of stylised Latin. Added to this the first two were hardly likely to be of great help to one another and the problems can be seen. The great tome should not be dismissed, it contains useful information and detail on life in England toward the end of the eleventh century. However this information can probably be carried in only 200 words, and these words would have been learned quite quickly. What was problematical were the proper nouns, that is people and places, and very often the odd phonetic spelling of Domesday is apparent when compared to other records from before and after 1086, the year of the survey.

Street names are normally much more recent and have been dealt with locally, making accuracy and change less of a problem. Furthermore many street names come from more recent times and are named for a specific reason, unlike the villages and towns which they serve. Often the street names from the eighteenth and nineteenth centuries, as people moved from the countryside and an agricultural way of life to the cities and the promise of greater wealth in the new industrial age, reflect the benefactors and bastions of industry and have a story to tell.

Public houses, as already mentioned, have a different background and need some understanding of how they first developed. The Romans provided the earliest signs, necessary in an illiterate society to advertise their wares. The basis for the inn sign, and thus the name, is the ale stake. This began as simply a pole, or more often a stripped tree, to which a sheaf of barley was tied to show the farmstead brewed its own ale and was available to travellers along with a bite to eat. Soon blacksmiths were located close to these ale houses, providing a mutually beneficial service to potential customers.

Soon not only blacksmiths but landowners, innkeepers, trades, families and national heroes and figures were adopted as icons adorning the signs outside the pub. Over the

years breweries and innkeepers have strived to produce more and more inventive ways of depicting traditional pub names – and humour is not just a modern idea. By far the most popular name in England is the Red Lion which, as with all oddly coloured animals in pub names, is heraldic in origin.

Thus we shall embark on a different way of looking at the history of Oxfordshire, through its place names. In the ensuing pages we shall find histories of places dating back 2,000 and more years, streets named after businessmen, adminstrators and local figures, fields named from produce and pastimes, and pub names almost having a language all of their own.

Chapter One

A

Abingdon

This town is first recorded as early as 968 as Abbandune, which by the time of Domesday in 1086 has become Abbendone. This is undoubtedly of Saxon or Old English origin and features a personal name followed by the well-known element dun. Unusually the individual is a woman being 'the place at Aebba's hill'.

Streets in Abingdon have been named from many different areas. Individuals include former mayors in the shape of Allder Close, Eldridge Close, Franklyn Close, Kysbie Close, Langley Road, and Spenlove Close. Another local figure is seen in Cameron Avenue which remembers the commanding officer of the nearby RAF station during the 1960s, Group Captain Neil Cameron.

The importance of car manufacture to the region is well represented. Captain Eyston was the racing driver for the MG manufacturing team during the 1930s, he is commemorated by Eyston Way, while Healey Close is named for the Austin Healey car made at the MG factory in the years following the Second World War. Kimber Road is named after the founder of the MG factory here, Cecil Kimber. The founder of Morris Garages Car Company, William Morris, is marked by the title he assumed for his work in Nuffield Way. It is pleasing to note the models are not forgotten, Midget Close is named after the sports car nicknamed the Magic Midget because of its much smaller wheelbase – a public house was also named to commemorate the Midget. The Riley Company was later acquired by Lord Nuffield, marked by Riley Close. National figures are not forgotten either, seen in names such as Elizabeth Avenue, which was named in 1977, the year of the silver jubilee of Queen Elizabeth II.

Bailie Close remembered Major-General Bailie of Caldecott House who died in 1918; Chaunterell Way was named from John Chaunterell who was mayor in 1576; Sir Walter Darrell was the first recorder in the borough from 1610-38 and is commemorated by Darrell Way; Sir John Golafre of Fyfield Manor gave his name to Golafre Road; with Kent Close named for the Mayor of 1873, John Kent; Norris Close recalls the MP for

the town 1857-65 John Thomas Norris; Sherwood Avenue was named after Edmund Sherwood, town clerk in 1662; and Wallace Close was named after G. W. Wallace, chief charity commissioner in 1926. Landseer Walk remembers the painter Sir Edwin Landseer; while local historian and author Miss Agnes Baker certainly earned the naming of Baker Road in her honour.

Not only the people of Abingdon but their lives and work are also well represented. Covent Close stands near the seventh-century Benedictine abbey, Pagisters Road is a corruption of pargeters or plasterers who once lived here. Picklers Hill is a much corrupted name from the owners of the land here, the Pulcher family.

No town could exist without an adequate water supply. The streets mark the course of two in Ock Street and Stert Street, while the stream was channelled into pipes along Conduit Street. Other aspects of life are commemortated too. Peachcroft Road was cut where a small croft or field was once the site of a grove of peach trees. Caldecott Close is an old regional name speaking of 'the cold or exposed cottages'. The wild plant Purslane has a name which doubles well as a street name, once gathered for use in salads, while Ginge Close is named after the Ginge Brook.

Town twinning, a popular method of cultural exchange in the late twentieth century, gave an opportunity for cultural awareness in lands abroad. This enabled those who were unable to travel to sample the taste of day-to-day life. Argentan Close is named after the French town of under 20,000, it is approximately 100 miles west of Paris. Bergen Avenue tells us of the city of Bergen-op-Zoom founded in 1266 in the Netherlands, on the coast it is very close to Antwerp. Coromandel is the region of New Zealand's North Island where there is a Firth of Thames and a town of the same name. Lucca Drive is named from the city of Lucca, with a population of 80,000 it is in the Tuscany region of Italy, not far from Pisa. A small town in the Bavarian alpine region of Germany gave rise to Schongau Close, and Sint Niklass Close after the city in the Belgian province of East Flanders.

Finally two street names which describe the street itself. Turnagain Lane is a name which could be employed more often than it is across the land, always used for a cul-de-sac. While there can be few names more delicious than Peep-o-Day Lane, which is aligned east-west and which affords views of the rising sun. Of course it also gives views of the setting sun and both are going to be changing throughout the year, which does cast some doubt on this definition but does not suggest an alternative.

Abingdon's public houses have examples of just about every genre there is. As already mentioned Ock Street is named after the river and the Ock Mill on the place where it was located. The Old Anchor Inn would have commemorated a landlord or owner who had earlier connections with the sea, the additional 'Old' is often applied to make a place appear more traditional (even when it has no age whatsoever). Similarly the Old Black Horse has the same addition, this time to an heraldic image, while the Spread Eagle symbolises the Roman Empire. Local references are found with the Ox Inn, which stands on the Oxford Road; the Boundary House close to the parish boundary; while the College Oak manages to combine two nearby landmarks.

Pub signs were recognised as potential advertising space from the earliest times, indeed the first known were simply that. Today the wheel has turned full circle in such names as the Punchbowl and Brewery Tap, however the welcome is more subtle in the grin displayed on the sign outside the Broad Face.

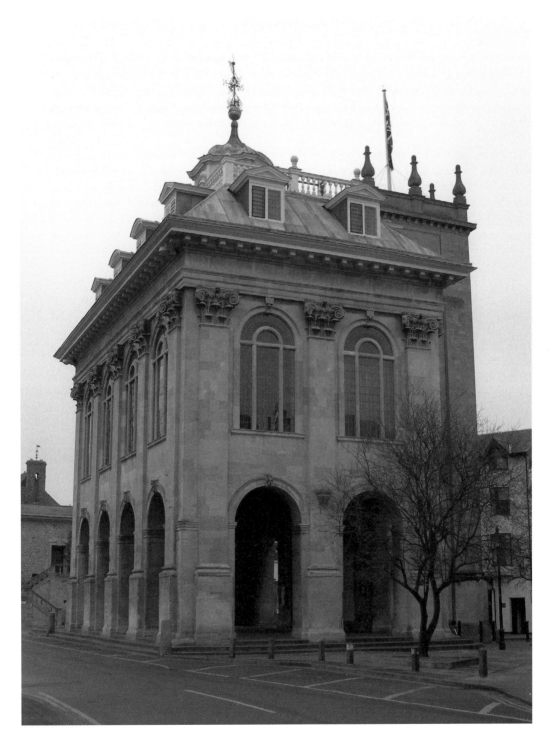

The market hall in Abingdon.

Adderbury

Actually two places officially, however East and West Adderbury are so close together - both geographically and historically – they can be covered as one. Records of this name begin in 950 with Eadburggebyrig, in the following years the name evolves exactly as would be expected in order to become the modern Adderbury. Here the origins are in 'Eadburh's burh or fortified place', with the personal name unusually being that of a woman.

Looking around the parish we find the name of Twyford Bridge, which is alone sufficient to inform us that this was previously a fording place before the first bridge was built. Furthermore it was 'a double ford' which suggests there was a seasonally dry area in the centre of the river. Not only the bridge has taken this name but also Twyford Lane and Twyford Wharf.

Adwell

A name which tells us this was 'Eadda's spring or stream', from the Saxon personal name suffixed by wielle. It is recorded as Advelle 1086, Agdoquell 1087, Addewell 1110, Edewelle 1175, Audewell 1225, Athewell 1428, and in its modern form for the first time in 1526. The region known as Adwell Cop is a reference to the ancient tumulus which is spoken of in the landscape and we would have known of its existence even if archaeological evidence had never been discovered, for there is a lane here which is named on maps from 1230 onwards as Copinghomewey and Copinghemewey - literally 'the way to the home by the copp'.

Field names here tell something of the history – Cowhovel would have had a rather dishevelled building to shelter the cattle; Droveway stood alongside the lane along which the livestock were herded by the drovers; but Sheep Baiting Ground is not what it seems, it refers to 'sheep pasture' and not an ovine blood sport. Home Pen tells us this was the fold for animals which was adjoining the farm buildings, the home of the farmer, with other fenced off regions of the same medieval farm shown on the modern map by Road Pen alongside the road, Pond Pen which afforded water for the livestock to drink, and Gausey Pen which would have had a good covering of gorse.

Akeman Street

One of the most famous roads in the country which is first found in the county in 1154 as Accemannestrete or 'Aceman's Roman road'.

Alchester

This place began life as a Roman station and stands on the crossroads of Roman roads linking Silchester, Dorchester and Towcester in one direction, and Cirencester and St Albans in the other. The common ending for all these names here is from old English caester refering to the Roman stronghold.

The first element is a Celtic element, a name which probably began as the name of a small stream meaning 'white water' but which here later also applied to the forest. Thus this is 'the Roman station of the Alauna forest'.

Alkerton

The only early record of note is from Domesday as Alcrintone. However this is enough for us to be quite certain this name comes from 'the farmstead associated with the Elahhere's people'. Here the personal name is followed by the Old English elements ing and tun.

Alvescot

Nearly all place names with the suffix cot are preceded by a personal name, and here is no exception. From over thirty records since the time of Domesday all clues point to 'Aelfheah's cottages'.

Kenn's Farm here was named after the eighteenth-century farmer John Kenn, where Langhat Ditch was named from the dialect term lanket referring to a long and narrow piece of land and, here, the ditch which drained it. The Shill Brook, itself named by back formation from the village of Shilton and scylf or 'shelf of land', in turn gave names to Shield Farm, Shield Ford, Shield Hedge, and Shield Hill.

Ambrosden

Another name found for the first time in 1086, when it was listed as Ambresdone. Here the first element is a little difficult to tie down. It could be a personal name followed by the element dun, an Old English place name meaning 'the place of or by Ambre's hill'. However the first part may be amer, in which case the meaning would be 'the place at the hill of the bunting', birds having many similarities to finches. Unless other early records are found it is unlikely that we will ever discover which is the true meaning.

Two local pub names of note here. Firstly the Turners Arms, which commemorates the Worshipful Company of Turners, formed in 1604 for men who turned wood on lathes, principally for domestic furniture. The other is the Penny Black, the world's first adhesive postage stamp. Issued in 1840 it shows the head of Queen Victoria and cost the princely sum of one old penny.

Appleford

This place has a name which is self-explanatory. From Old English aeppel-ford this is 'the ford where apple trees grow'. It is also known as Appleford-on-Thames, the addition referring to its close proximity to the famous waterway.

The local here is the Carpenters Arms. Featuring the coat of arms of these ancient craftsmen, it suggests an early landlord was formerly associated with same.

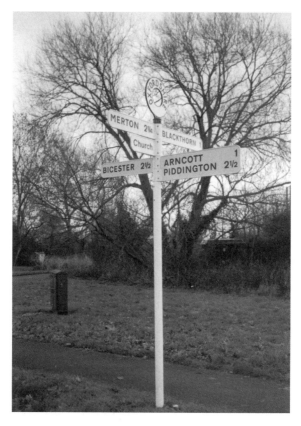

A road sign at Ambrosden.

Appleton

As with the previous entry a name of fairly obvious beginnings, indeed the most surprising thing about this name is there is no addition as five of the other six similarly named places in the country do. From Old English aeppel-tun, this is 'the farmstead with or near the apple trees'. The place is recorded in Domesday as Apletune, little different from the modern form or that in a document of 942 as Aeppeltune.

Ardington

A place which, until the redrawing of the county boundaries in 1974, had been a part of Berkshire. Listed in Domesday as Ardintone, this name comes from the Old English telling us of 'the farmstead associated with the family or followers of Earda'.

The local here is the Boars Head, which undoubtedly comes from an heraldic badge. However it is such a common symbol since the days of Richard III, who was known as the Boar, and passed it to many important and influential families of his day, that it is found in many coats of arms and is impossible to tie down.

Ardley

In 995 this name appears as Eardulfes lea and in 1086 as Ardulveslie, both of which show this to be a Saxon name telling of '(the place at) the woodland clearing of a man called Eardwulf'. The suffix here is ley, a common element referring to a natural or existing clearing.

The local here is the White Lion Inn, one of a number of oddly coloured animals found used only as pub names. These are heraldic in origin, most often taken from the coat of arms of the lords of the manor.

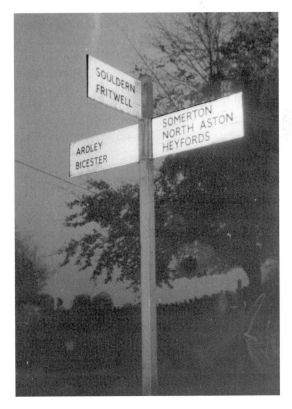

Ardley road sign in the early hours of the new day.

Arncott

Officially there are two places, Upper and Lower, separated by a distance of approximately 500 metres. Lower Arncott, even today a very tiny group of buildings, lies to the north of Upper Arncott. There is little obvious difference in the elevation of the two places and therefore the additions refer to the stature or size of the respective settlements.

The basic name is found as Earnigcote in 983 and as Ernicote in 1086, coming from the Old English personal name and the elements 'ing' and 'cot' and telling us of 'the

cottages associated with Earn's people'. It seems certain the smaller place began life as an outlying settlement and probably only gained the addition of 'Lower' from a cartographer who decided some defining element was necessary, for there is no mention of these additions locally.

One public house name found here has a tale to tell. This was the cry which went up when the hunt spotted the fox, or similar prey. The etymology of tally ho is unknown, although there have been numerous creative suggestions, including the French *il est haut* meaning 'he is high' and showing to what lengths some will go in order to create an etymology. What is known is that was the basis for several inns and taverns where the hunt met, and also for at least one nineteenth century stage coach and for the Tally Ho Hotel.

Ascott under Wychwood

First recorded in 1220 as Estcot, this is from the Old English east-cot or 'the eastern cottages'. As with the vast majority of place names this was coined by neighbouring settlements, here one of those to the west. The addition is to differentiate from others close to here, even though they may have a slightly different spelling.

Ascot d'Oyly here is also from 'the eastern cottages', which was the domain of Wido de Oileio around 1100. Ascot Earl recalls 'the eastern cottages' which were held by the le Despenser family, Earls of Winchester. Boynal Copse tells us this was 'Boia's nook of land'; Wychwood is an older name referring to the forest and found attached to a number of names locally. First recorded in 840 as Huiccewudu, it speaks of 'the wood of a tribe called the Hwicce'.

The local here is the Swan, a name which has two equally possible origins. It was often chosen simply because of the serene image of one of the world's most majestic birds, however it was also an heraldic symbol used in the coat of arms of both Henry VIII and Edward III.

Asthall

A parish listed as East Heolon in the early 11th century, Esthale in 1086, Asteles in 1185, Estale 1220, Asthall 1246, Easthalle 1278, and Aschall in 1285. While the modern form is undoubtedly from east-healh, 'the eastern secret place', the earlier records suggest the name was plural. Just why there were many 'secret places' here is not recorded, yet there are references to a number of hollows in the hillside and perhaps these were the secret places. Sadly we will only ever be able to guess at their uses.

Here minor names include Asthall Leigh or 'the woodland clearing of the people of Asthall'; Field Assarts refers to 'the cleared former wastelands belonging to Leafield'; early records of the name of Fordwells tells us the original name was Sewkeford or 'the ford of the stream of Seofeca'; Pinnel Spring has changed little since it began as 'Pinna's spring'; Worsham Mill and Worsham Turn both refer to 'Wulfmaer's homestead'; and Hick's Plantation remembers the mid-sixteenth century farmer Jone Hykes. Curiously the name of Stanridge Copse is now the name of an entire wood and comes from 'the stony ridge'; Stockley Copse is quite the reverse and takes its name from 'the woodland clearing of the tree stump'.

Aston

A village east of Bampton which was perfectly describes the origin of this name. From Old English east-tun this is 'the eastern farmstead', and most likely named by the neighbouring village.

The local here is the Flower Pot. Today it is seen as an ordinary name taken from the standard list of pub names, yet to get on that list it took a great deal more effort on the part of landlords than most. The earliest records of the name of flowerpot began in the seventeenth century. Prior to this the flowers and not the pot were the important image, for invariably the flowers were lilies and representative of the Virgin Mary. When Puritanism was dominant, their dislike of saints and symbolism meant innkeepers needed to find a more subtle way of representing the same thing and transferred their attention to the pot, which also had the advantage of being a very simple (and therefore cheap) sign to produce.

Aston Rowant

Recorded in 1086 as Estone, in 1110 as Eastuna, in 1246 as Aston, and in 1318 as Aston Roaud, the basic name here tells us this was 'the eastern tun or farmstead'. Here the addition comes from the lord of the manor Rowald, who had lands here in 1235. Interestingly there is a solitary record showing a different family, in 1316 the name is given as Aston Sancte and a reference to the family of John de Sancta Elena who is also listed as having land in neighbouring Crowell in 1295.

Minor names of interest here abound. Chalford reflects the landscape around Oxfordshire as it describes 'the chalk ford'. Kingston Blount is 'the royal manor associated with Hugo le Blund', a lord of the manor who was here by 1274. Nearby is Kingston Stert, featuring the same first element but here with steort and giving 'the royal manor on the tongue of land'.

Field names here include Butterday which refers to the quality of pasture, a major factor in the decision of where to site a dairy farm; Buttocks Furlong was named after John Buttuck, who was here in 1415; Further Hudes comes from 'the more distant hades', the head or strip of land which remained unploughed as this was where the plough turned; Shittle Field was a muddy or dirty place, not condusive to ploughing; and Winterdole the 'allotment of land for the colder months'.

Cop Court and Upper Copcourt Farm would probably be offered as referring to a copp 'a tumulus or earthwork', and such does exist not one mile away. However, not only would be expect to find the earthwork much closer to the place, and none has ever been traced here, but we would not expect it to be coupled with the element cot 'cottages' but with a personal name. However the forms available make the personal name uncertain, thus the cottages could be associated with someone called Coppa, Cobba, or Cubba.

Aston Tirrold

As with that of Aston above, this is 'the eastern farmstead'. This very common place name more often that not has an addition for distinction. Here it is recorded as simple

Estone in 1086, yet by 1318 it is Aston Torald. This comes from the Thorald family who were here by the twelfth century.

The local here is the Chequers Arms, one of the oldest pub names dating back to Roman times. Indeed there is evidence to suggest there was an inn called Chequers in the streets of Pompeii before it was buried by the ash thrown out Vesuvius famously erupted. In the days when the majority of the population were illiterate symbolism played an important part in advertising and display. A game called chequers, not draughts but very similar, was played in a number of inns and, in order to advertise such was available, the innkeeper hung a chequerboard outside as the sign. Shortly afterwards the sign was also used to inform prospective patrons that this particular landlord was also able to act as a banker. It is from this same root that we get our the term 'exchequer'.

Chapter Two

B

Badgemore

A name recorded as Begevrde 1086, Bagerigge 1181, Baderug 1186, Beueregge 1285, Baggrugge 1361, and Bugerugge 1361. This shows the Old English suffix hrycg with a personal name and telling us it was 'the ridge of land associated with a man called Baecga'.

Here the name of John Mancorn gave their name to Mankorn's Farm, while No Man's Hill is so called because of its close proximity to the county boundary.

Bainton

As place names go this is among the newest. It was created in 1970 and named after former mayor Raymond Bainton, who was instrumental in its creation, and forty years later the population is still under two hundred.

There are two other Baintons in England, in Cambridgeshire and Yorkshire. Examining the origins of these names and we find they come from 'the farmstead of the family or followers of Bada and Baega' respectively. The ancestors of the village's founder would have come from one of these two places.

Hence we find an individual who has given his name to a place, which in turn became a family surname and has now been transferred to a place again.

Baldon Brook

Listings of this name include Humelibrok 1240, Homerinbroc 1279, Homeling Brook 1657, and Humble Brook in 1840. The modern name has been taken from the place name (see Marsh Baldon and Toot Baldon), from 'the hill of a man called Bealda' and is not seen before 1927.

The earlier name is derived from Old English hymele, a plant name which has been known to be used to refer to both the wild hop and bindweed, either of which may have grown here.

Bampton

A name listed as Bemtun 1069, Bentone 1086, Beanton 1195, Baunton 1199, Bamton 1208, and in the modern form as early as 1212. With its origin in Old English beam-tun the name has two possible meanings. The easist derivation to offer is 'a farmstead by a prominent tree', however the name could refer to 'the farmstead made of beams' and representative of a (then) new building technique.

Locally we find Burroway Bridge, 'the path to or by a burial mound', which has also given a name to Burroway Brook. The former gatehouse of Bampton Castle, built by Aymer de Valence, Earl of Pembroke in the early fourteenth century, is now known as Ham Court 'the manor house of the water meadow'. A wetland theme is also continued by Rushy Weir or 'the island of the rushes by the weir'. Weald is a name found around the country to refer to 'open land in former forested country'; while the 'remoteness name' here, given to the furthest corner of the parish, is today only seen in Isle of Wight Bridge.

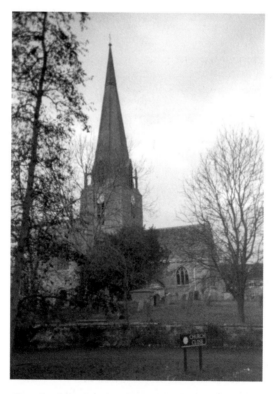

Church of St Mary the Virgin, Bampton.

Banbury

An Old English place name listed in 1086 as Banesberie. This comes from the Saxon burh, telling us this began life as 'the stronghold of a man named Banna'. We shall never know who the individual was, however he was certainly not here at the time of Domesday when the settlement was held by the Bishop of Lincoln.

In Banbury is Cherwell Street, named after the river; High Street, was the most important road in the town; Horse Fair shows where the animals were sold; Monument Street marks the site of a former obelisk, now removed, and itself erected to show the site of the South Bar or 'closable gate to the town' and complemented the North Gate; and Old Parr Road recalls 1747 and the public hanging of a murderer of that name on this site, and who probably remained here in a gibbet for some time as a warning in order for his name to be taken for the street.

Within the region of the town we also find minor place names. Berrymoor Farm comes from 'the fortified place on the moor'; Bretch Farm was once 'the land newly taken for cultivation'; Calthorpe House was erected on 'the gulley with the thorn bushes'; Crouch Hill Farm reminds us of the British crouco meaning 'hill' being completely unknown to the Saxons who added their own hyll and gave 'hill hill farm'; Easington is a place which began as 'Esa's valley'; Hardwick Farm is 'the farm of the flock'; and Wykham Farm speaks of 'the homestead of the dairy farm'.

However the most interesting name is that of Grimsbury, a name coming from 'Grim's prehistoric earthwork'. In this combination the name can only refer to a god-like being. Sometimes grima is seen as 'mask' and related to Grimr an Old Norse term used to refer to Odin when he was in the disguise. Clearly this place was a very important religious site, however any useful archaeology disappeared centuries ago and no evidence remains.

Lancelot Ernest Holland (born September 13th 1887) was raised in Banbury and joined the Royal Navy on 15 May 1902. Rising through the ranks he went down with his ship, H.M.S. Hood, sunk by the Bismarck in May 1941 at the Battle of Denmark Strait. The Admiral Holland pub is a fitting tribute to a less well known naval hero.

The Banbury Cross Inn is a reminder of the town's most famous feature, known to children elsewhere through rhyme well before they are aware of the place. The Priory is also represented by a school and is a reminder of a former place of worship. However the most welcoming name must be the Flowing Well, named after the natural spring nearby it suggests it is the ale which is flowing within.

Trades honoured by the inns of the town include the Butchers Arms, Jolly Weavers, and the Woolpack Inn, while the Cricketers Inn tells of where the sport was founded here. Families are also represented: the Marlborough Arms, the title given to the Churchill family resident at Blenheim House, a reward for a soldier and statesman, John Churchill being a close friend of Queen Anne; while the Lampert Arms was built as a railway hotel and named after Captain W. L. Lampert who lived for a short time at the house called the Highlands. The Hanwell Arms is not a family name but is named after the nearby village.

Animals make good subject matter for a sign. They are not always heraldic in origin, normally only those preceded by a colour. These creatures are easily recognised and remind us of the countryside. With its antlers providing excellent imagery, the Olde Reindeer Inn is also associated with Christmas. It has been suggested that the Three

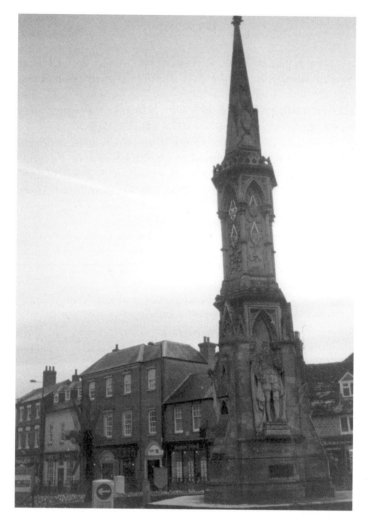

Banbury's famous cross.

Pigeons and Three Conies Inn have names which started life as a menu but, as with the Pepper Pot, is just a simple image.

Nearby is the name of Calthorpe, derived from Old English it has been corrupted over the years and was originally col-throp meaning 'the outlying farmstead where charcoal was produced.

A local place name here is Neithrop, which is found as Ethrop 1224, Nethrop 1278, Hethethrop 1285, and by the early eighteenth century closer to the modern form of Neithrup. The 1285 record here is an error and can be ignored, which leaves two possibilities. Either this is from nether - throp 'the lower outlying farmstead', or atten - aest - throp or 'at the eastern outlying farmstead'. The loss of most of atten is to be expected, when the following element begins with a vowel the reduction to just the 'n' is not only common but to be expected.

Barford

Two places very close together which are linked historically as well as geographically. The basic name is a common one and comes from bere - ford or 'the ford where barley is grown nearby'.

Today the two names are suffixed by the dedications of the respective churches, giving Barford St John and Barford St Michael. During the thirteenth century Barford St John appears as Bereford Plaice, a reference to the lords of the manor of which Henry de Plesy is mentioned in 1364, while Barford St Michael mentions a Garin de Plaiz in a document of about 1170. This family were never lords of Barford St Michael, as far as we know, however there is a record of the place being referred to as Bereford Chayney and doubtless taken from the name of the family of Dionisia de Cheineto, also named in a twelfth-century document.

Barton

From Old English bere - tun, this 'the farmstead where barley is grown'. It is listed as Berton in 1246, Aldebarton in 1246, Oldebarton in 1278, Bartone in 1285, and Oldbarton in 1316. The addition of eald in some of these examples tells its own story. Whilst the obvious meaning is 'old', it is probably used here to mean 'disused' and tells us this particular settlement had previously been abandoned and resettled.

Local place names include Bayswater Hill, named after Bayswater Brook (see below), which was previously called Karshulle (1221) from caerse - hyll meaning 'cress hill'. Kings Mill is so named, not because this is king's land, but because the mill was granted by a charter of Henry II. Sand Hill has only been known as such since the early seventeenth century, prior to this it was Sandene 'the sandy valley' which carried the name and which gave this rather inappropriate name to the hill. The Drift is a field name taken from the lane running alongside it which was used for driving livestock on a regular basis, while the Freeboard is a term for a strip of land which probably lay outside the main boundaries of the district but which was nevertheless retained by manor.

Bayswater Brook

In 1220 this water course was referred to as Ludebroke, meaning 'the loud brook'. By 1676 it is known as Bayard's Watering Place which is always the name of a horse and which was clearly pastured here. Nothing was recorded concerning the horse in question, thus it was probably not a champion but a much-loved member of the family who was here for many, many years.

Beckley

Records of this name have been found as Beccalege 1005, Bechelie 1086, Becceleam 1108, Bechlea 1167, and Becle 1192. This shows the origins to be Old English for 'Becca's woodland clearing'.

Here is Stow Wood which, from earlier records, would show this comes from stan-wudu and telling of 'the stony wood'. Sidlings Copse is taken from the Middle English describing 'the wide woodland clearing'. There is a record of a Parkemede in 1375, telling of 'a hunting meadow' and being tended by John le Parker (the park keeper) from about 1340. During the thirteenth century this region was laid out as a chase by Richard, Earl of Cornwall, and this is obviously a remnant of same. The park also gave the place names Upper Park Farm, Middle Park Farm and Lower Park Farm.

Landholders would bequeath areas of land for the use of the poor, and particularly widows of the parish, such areas are often named to show this and here we find Poor Folks Pasture Gate. The drain which pulls the water from the common land gave the name to Vent Field. Cut Field tells of a place where the former land was 'cut into strips' to provide more agricultural land. Fowls Pyll comes from 'the small stream where waterfowl are found, probably used as a food source. Cuckoo Pen tells us this was a sheltered field and the name alludes to the tales of the Wise Men of Gotham and the tale of the cuckoo which they attempted to cage by a low fence and thus prevent the migration of the bird and prevent the onset of winter.

Begbroke

Records of this name as Bechebroc 1086, Bikebroc 1233, Beckbroc 1235, and Brockebrok 1284, show this name to have originated as 'Becca's stream'.

Benson

From the first record as Baenesingtun in 900, through Bensintona in 1140 and Basingtun in 1217, to that of Benston in 1526, this name is undoubtedly of Old English origin and was 'Benesa's farmstead'.

Here is Crowmarsh Preston 'the marsh where crows are seen, associated with the priests', and that of Crowmarsh Battle Farm is 'the marsh of the crows which belonged to Battle Abbey'. Fifield gets its name from 'the field of five hides', a Saxon land measurement; Mogpits Wood comes from 'Mucga's pits near the woodland'; the name of Oakley Wood tells us of 'the woodland clearing in or by the oak trees', a common name also seen nearby with Oakley Little Wood; Port Hill refers to 'the hill by the town'; Turnerscourt Farm is named from the manor house which once belonged to, or was even founded by, a man called Turner.

The field name of Bell Wether Furlongs is where the male rams were kept; Bottle Hill Furlong described the shape of the piece of land; Callow Piece comes from calu meaning literally 'bald' but here used to describe bare land or soil; Foul Slough Close comes from Middle English ful-sloh and tells of 'the dirty or foul fenland', a very muddy field at most times of the year.

Berrick Salome

One of the most delightful and unique names in England. In 1086 it was listed as Berewiche, while the addition is not seen until 1571 when it appears as Berwick Sullame. The basic name is of Old English or Saxon origins from bere-wic, 'the barley farm'.

The addition seems to be rather later than usual, if this is indeed the earliest record, making it likely that scribes were 'encouraged' to add the name to the place – an early example of the de Suleham family wanting to make their mark perhaps.

The Hangings is a field name which often leads to local legends about gallows, executions and lynchings. However the true origin is quite simply Middle English hangende described land on a slope, simply 'overhanging land'.

The name of the Chequers public house is derived from the Roman practise of hanging a chequerboard outside the premises to advertise this game was played within. It also doubled as an indication that the innkeeper would act as a banker, hence the term 'exchequer'.

Bessels Leigh

Another place name with the addition of the name of the lords of the manor, however this time the family name is seen in the first part. The Besleys family were here by 1538 when the place was recorded as Bessilles Lee. Earlier in 1086 we find the name as simply Leie. This is derived from leah, a common place name element usually seen as the suffix -ley and describing a '(place at) the woodland clearing'.

The Greyhound at Bessels Leigh is a quite common pub name. Older names will be an heraldic reference to the Dukes of Newcastle, while more contemporary names will refer to greyhound racing.

Bicester

This name is first seen in Domesday as Bernecestre, however the lack of other examples makes the first element a little confusing. This is most likely from Old English beorn - ceaster, which would give 'the fortified place of the warriors' and a clear reference to the nearby Roman station. However the first may have been used as a personal name, probably a nickname for a much-respected and battle-hardened individual.

Minor names around Bicester include Bignell House is named from the estate, itself coming from 'Biga's hill'. Crockwell is a region which takes its name from the stream where fragments of pottery have been discovered, it is uncertain if these were genuine archaeological relics or pieces of a broken pot. Graven Hill takes its name from 'the wooded hill'. Himley Farm has two possible and rather different origins, either this is hymele a plant name which has been known to be used as a place name, or it could be imbe meaning 'a swarm of bees' – although the second would be less likely as they would have hibernated, and thus not a permanent feature, and the normal terminology in a place name refers to the hives or the honey.

Langford Farm is named after the 'long ford', meaning it was spanned a wide, wet area rather than the width of the ford itself. Market End was named for it being the location of a new market which was granted herein the middle of the sixteenth century, prior to this the place was known as Burh or 'fortified place'. The Diggons is a region of 'newly cleared land for cultivation'. Croney Lane is an area which should be coney and refer to 'the area of the rabbit warren'.

The name of Wretchwick takes its name from Old English wrecca - wic, the first element has evolved to the present 'wretch'. The use of this term would be understood to be 'exile', indeed it is most likely being used here as a personal name or as a nickname. However one of the most unusual field names in the county must be that of The Pesthouse. It refers to a quarantine region, a building referred to as a lazaretto (after the Biblical figure of Lazarus) and would have been for suspected plague carriers.

Locally we find the names of the public houses reflecting the history of the region. Formerly known as the Maltster's Arms, it was changed to the Whitmore Arms following the tenure of nearby Hethe House of Thomas Whitmore from 1808. A Shropshire family, the Whitmores must have invested in the business to justify the change of name when they were only here for three years. The Centurion is a reference to Bicester's historic links with the Roman occupation, a centurion being the officer heading eighty men. Here there will be arguments for the traditional idea is a force of one hundred men – a century. However the exact number varied from a hundred down to as little as sixty until the Marian Reforms of 107 BC, when the number was set at a standard eighty. Here the sign is of a most imaginative design, depicting the Roman god of war, Mars, overseeing a Roman centurion running away from an advancing centurion tank.

A hundred was a subdivision of a shire in early Saxon times, not an exact measure it was roughly the amount of land required to support a hundred extended family units. Clearly this depended more upon the fertility of the soil and the size of the family than it did quantifiable dimensions. By the time of the Normans it was seen as an administrative division. The name of the Hundred Acres public house most likely refers to an area of common land upon which it was built. It cannot refer to a field of this size for they simply did not exist.

Fauna and flora have long been a favourite subject for innkeepers, especially when they also reflect the coat of arms of the lord of the manor or other digitary. The Red Cow is a simple enough sign to produce, reducing costs, and an example of this heraldic origin. Considered a term of delight today, the Nightingale is known for the sweetness of its song or an association with *Ode to a Nightingale* by John Keats. However before naming your home for similar reasons, you should be aware that in the nineteenth century it was also used as a euphemism for a prostitute. Finally the Oak has given the opportunity for a great number of theories as to its origin. Despite ideas of 'from little acorns', or 'longevity', or even alluding to the small size of the place, these are fanciful explanations and the true beginning is it is a simple and easily recognised image.

Binfield Heath

As with the name of Bicester, it is unclear from the records available if the first part is a personal name. Here we find a record of Benifeld from 1177, the addition is not seen before the sixteenth century and has obvious meaning. The basic name is likely from beonet - feld, giving 'the open land where bent grass grows'. Clearly grass does not grow bent but collapses due to the effects of the weather. Thus we can deduce this would be describing land where grass grows but is not grazed. However the alternative could be the personal name Beona, further early records are required to decide.

The Bottle & Glass public house has a name which is an obvious advertisement of what can be expected to be found within. It is interesting to note this name was never found before the end of the seventeenth century, for the simple fact that beer was not bottled before this date.

Binsey

A Saxon place name, listed as Beneseye 1122, Buneseie 1141, and Beneseya 1291. This is undoubtedly from 'Byni's island'. The suffix here is eg which certainly describes this region which is almost enclosed by quite substantial water courses.

Minor names here include Godstow, which is found as Godestowe in 1150, Godestoke in 1428, and Godstowe in 1526. This is 'the place of God', a reference to the Benedictine nunnery which was founded in the twelfth century. Medley Manor Farm and Medley Weir recall the middel-eyt or 'middle island', telling us the farm was situated on dry land in a marshy area midway between Binsey and Osney, with the weir taking its name from the farm.

Bix

Listings of this name include Bixa 1086, Bixse 1166, Bixe 1201, Byx Gybewyne 1240, Bixe Brond 1285, Bixebraund 1300, Brixebrond 1268, and Buxe Jebywine 1316. The basic name here, that which survives to the present, is derived from Old English byxe, used as either '(place at) the box tree' or perhaps 'the box grove'. Such a simple name has, as the forms show, attracted a series of additions. Although these are no longer in use they should be examined as they do provide some information regarding the history of the place and show the influence of the families of Ralph Gibbewin (1165), John Brond (1254) and Robert Brand (1275), although the last two are almost certainly related and the name is simply recording wrongly in one of the cases.

Local names include Bromsden Farm is named from 'Brun's hill'; Redpitsmanor Farm really was 'estate with the red clay'; although Westwood Manor is not a literal name, it is a corruption of 'the place of a family called Wace'. Warmscombe Lane takes its name from Warmscombe Firs, the name meaning 'Waermod's valley'; Broom Pightles is 'the piece of land where broom grows'; Cats Slipe is probably 'Cate's strip of land', although the personal name is not certain; Butter Field is named from 'the field with good pasture', i.e. a dairy farm famous for its butter.

Blackbird Leys

A name which began life exactly the same as the vast majority of Saxon names, as that of a farm. However the difference here is the timescale, for this was not seen until the eighteenth century with the first record dated 1797 as Blackford Lays. The name which means 'the dark ford at the clearing' has been corrupted to the present name and is now a well developed residential area.

Black Bourton

A name derived from the Old English burh-tun and meaning 'the farmstead by the fortified place'. The addition of 'Black' is an indirect reference to the landholders of Osney Abbey and the monks in their black habits who worked this farm.

Locally we find Elmwood House, the estate being alongside 'the wood of elm trees'; and Garson's Close from gaers-tun and 'the farmstead with the paddock for horses'.

Blackthorn

Although there is also a record of a Blackthorn Bridge from the sixteenth century, the name of the place had already been recorded for at least five centuries. This is undoubtedly from the name of the shrub which must have been particularly prolific here.

Another bridge is later found and referred to as Heath Bridge, although historically this was 'the bridge of heathland border stream'. The field known as the New Diggins is named from quarrying which happened near here; Bayard's Green is a field name used to tell it was where a horse was pastured; and The Poor's Houses was left to provide for the parish poor.

Bladon

A place name which undoubtedly comes from the old name of the River Evenlode. It has been suggested as being British, mainly because there is no credible Saxon etymology, yet there is no known Celtic word which suggests itself as the origin for this name.

The White House pub is a connection to Sir Winston Churchill. The former British statesman is buried at Bladon. He was made an honorary American citizen, the nationality of his mother by birth, hence the picture of the White House of Washington DC on the sign and the flying of the Stars and Stripes on the flagpole.

Bletchingdon

A place name found as Blecesdone 1086, Blechesdune 1123, Blegedun 1185, Blechedone 1201, Blacchesden 1260, and Blechyndene 1526. It is derived from the Old English for 'Blaecci's hill'.

Around here we find minor names such as Beanhill Barn, from 'Beowa's hill'; Black Leys refers to 'the place at the dark wood'; Underdowns is 'the place under the hill'; while Gibraltar is the 'remoteness name' for this village. Field names include Great Athersome and Little Athersome named from 'Aelfraed's water meadow'. Great Bread Croft and Little Bread Croft are misnomers and should be 'the broad field'. Hag Bed features the dialect term for 'the hawthorn piece of land', a rather unkind name for an area which must look delightful when the hawthorn is in blossom.

The local pub is the Oxfordshire Inn, a name declaring a pride in one's home.

Bloxham

Listed in the eleventh century as Blochesham, this name comes from a Saxon personal name with Old English ham. This may be little evidence but we can still be certain this was originally 'the homestead of a man called Blocc'.

Within the parish we find Upper Grove Mill and Lower Grove Mill, which are more likely named from Osbert de Grave who, in 1238, is said to be the owner of the Grove Mill. As there is no evidence it existed before this time, it is likely the name came from the owner of the mill rather than any topographical feature. Cumberford is 'the ford in a valley'; Hog End 'the field where domestic pigs were reared'; and Hobb Hill could be 'the hill of the hobgoblin' but the more likely origin is a personal name.

Local inns include the Joiners Arms, displaying the coat of arms of the Company of Joiners, a trade differing from carpentry in producing more ornate and lighter work. Although it is not as obvious, the Elephant & Castle is also a reference to a trade, that of the Cutlers' Company. Their crest features a small castle on top of an elephant, the pachyderm probably chosen as ivory was often used for the handles of the cutlery.

Bodicote

With records of this name found as Bodicote 1086, Budicote 1180, Boidecot 1220, Bidicote 1239 and Bedecote 1285, this name comes from 'Boda's cottages'.

Locally we find the name of Weeping Cross which is found in various counties and always at crossroads. There has been much conjecture as to the origins, any or all of which could be the origin. Such points are traditionally held to be revered sites, markers of a cross making it a place of worship or penitence. Crossroads are also where a funeral procession would rest, and tears shed by the mourners. Crossroads were always the site of burials for those not able to be interred within consecrated ground, suicides for example, and are often claimed to be haunted by the saddest of spirits unable to find peace in the afterlife. It seems the real origin will never be known.

One local recalls the trade of an early innkeeper as the Bakers Arms.

Botley

A name found elsewhere in England, here not until the twelfth century as Boteleam. This is from the Old English bot-leah, giving 'the woodland clearing where timber is obtained' – literally an early lumber yard.

One of Botley's most popular pubs recalls one of its forgotten villages. The Seacourt Bridge Inn stands alongside an old culvert which ran through the village of Seacourt, which was crossed by the bridge referred to in the name. Now a part of Botley, this name is recorded as early as 957 as Seofocanwyrth and is derived from Old English for 'Seofeca's enclosure'.

Bourton

Actually two places, Great Bourton or Magna Burton and Little Bourton or Parva Burton, these names refer to the 'large fortified farmstead' and 'small fortified farmstead' respectively.

Brightwell

This place name is not as unusual as one would think. Indeed this is one of two in the county of Oxfordshire alone. They all have one thing in common, being some of the earliest recorded settlement names still in existence. Found as Beorhtawille in 854 and Bricsteuuelle in 1086, this is clearly from the Old English beorht-wella and means exactly what it seems today '(the place at) the bright or clear spring'.

Brightwell Baldwin

As with the previous name this comes from beorht - wella '(the place at) the clear or bright spring'. The name is recorded as Berhtanwellan in 887 and Britewelle in 1086. To distinguish from the previous name the lord of the manor added his name of Sir Baldwin de Bereford, who was here in the late fourteenth century.

Local names of note include Caldwell Covert Farm, 'the spring or stream of a man called Cada' has given its name to a small wooded area and from there to the farm which occupied that land.

Britwell Salome

Listed as Brutwelle in 1086 and Brutewell Solham in 1320, the addition features the same family as gave their name to Berrick Salome, namely de Suleham who were here from the thirteenth century. The addition is to distinguish from Britwell Prior, a place owned by the Prior of Christchurch, Canterbury and confirmed by a charter of Edward the Confessor in 1045.

The basic name comes from the Old English bryt-wella, the '(place at) the spring or stream of the Britons', the peoples who inhabited these islands before the Anglo-Saxons arrived.

Cobditch Hill takes its name from two pre-Roman features found here. The elements copp and dic tell us this was 'a tumulus in the earthwork'. Shambridge Wood is an erroneous name, for there is no bridge or river here. The name comes from sand - hrycg or '(place at) the sandy ridge'. Chaffhill tells us this was 'the hill where calves are reared', and Worm Croft was 'the field populated by snakes'.

Brize Norton

Domesday lists this place in its simplest form in 1086 as Nortone. This is one of the most common of all place names and predicably among the most simple. Named by

a neighbouring settlement to the south it refers to 'the farmstead to the north'. The addition, first seen in a record of 1266 as Northone Brun, refers to the landholder William le Brun who was certainly here in 1200 and probably before.

Within the parish are the name of Astrop Farm 'the eastern outlying farm'; Haddon Farm is something of an oxymoron as 'the uncultivated hill slope'; Marsh Haddon Farm 'the marshland by the uncultivated hill slope'; Chequers Garden and Chequer Orchard are both named from the former Chequers Inn, itself an early inn sign telling of both a board game and later a money lender (exchequer) within'.

The name of the Masons Arms public house probably recalls the trade of an early innkeeper.

Broadwell

A quite common name which we would normally find as closer to the original Old English as brad-wella (Bradwell). However here the name of the '(place at) the broad stream or spring' has evolved along with the English language. The name was recorded in Domesday as Bradewelle.

Broughton

Listed as Brohtune in 1086 and Broctona in 1224, this is a common place name found throughout England. There are three possible origins for this name, yet it is often difficult to distinguish between them. Here the most likely origin is Old English broc - tun, meaning 'the farmstead by a brook'.

Local names include Pike Farm, Little Pike, Great Pike, and the Pike Barn, all of which took their names from the pointed or pike-shaped area of land here which Saxons described as the picked.

Broughton Poggs

Records of this name are found as Brotone in 1086 and the first time with the addition for distinction in Broughton Pouges as late as 1526. As with its namesake above this is 'the farmstead on the brook', while the addition refers to the lords of the manor from at least the sixteenth century, the Pugeys family.

Bruern

A name listed as Bruaria 1159, Bruir 1162, Brueria 1172, and in the modern form as early as 1200. This is a name of Old French derivation from bruiere and meaning simply 'heathland'.

Here we find minor names such as Tangley Hall and Tangley Wood, where the basic name speaks of 'the woodland clearing by the River Teign'.

Bucknell

Domesday's record of Buchehelle is the only early form of note. However it is sufficient to see this most likely comes from Old English bucca - hyll, meaning 'the hill where he-goats are grazed'. However there is a possibility the first element was used as a personal name, in which case this would be 'Bucca's hill'.

Burford

The only early record of note here is, once again, found in Domesday. The eleventh century record of Bureford is from Old English burh-ford, 'the river crossing by the fortified place'. Whilst mention of a fortification brings to mind the idea of major castles and strong stone walls, in truth the vast majority were simply manor houses which had been strengthened or a defensive ditch and/or embankment added.

The Angel is a pub name which has been popular for many years. It points to the age-old link between the pub and the church and gives signwriters a simple image to work with, as does that of the Mermaid. The Royal Oak is the second most common name in the land, recalling the Boscobel Oak in which Charles II and his aide, Colonel Carless, hid to escape the pursuit of the Roundhead soldiers following defeat at the Battle of Worcester in 1651. The Cotswold Arms is, of course, a direct reference to the range of hills but probably an oblique reference to the breed of sheep of that name which provided wool and was tended by a number of the customers.

Chapter Three

C

Cane End

A name which makes more sense if we look at the sixteenth-century listing of Canonende. This place was held by the canons at the monastery of Notley. The name of Reade's Lane is connected with Edward Reade, who owned land here in 1606.

Carterton

While this may seem a typical Saxon name, and indeed this was deliberate, the village was not founded until 1901. It was named after its founder, William Carter.

Neither the town nor air travel is particularly that old, therefore a little literary license has been exercised in the name of Ye Olde Aviator. Incidentally, the addition of 'Ye' is almost entirely exclusive to pubs and, while we might think it sounds old, it is a fairly new development in such usage. We also find the Bee Hive, a name synonymous with industry and a natural product – a potent advertising combination.

Cassington

There are numerous records of this name, which give a variety of spellings for a name with an origin in Old English caerse – tun or 'the farmstead where cress grows'.

Local names include Burleigh Farm, 'the wood by an earthwork'; Purwell Farm, 'the stream of the pear trees'; Worton, 'the farmstead where herbs and/or vegetables were grown', thought to be unusual or even exotic food products and therefore having a regular and wealthy market for same.

Caversfield

A name listed as Cavrefelle in 1086, Caveresfeld in 1222, Caueresfeld in 1247, and Camersfeld in 1326, this comes from Old English and 'Cafhere's open land'. This personal name was probably a nickname, or at least started out as such, and would have been related to caf meaning 'bold' or 'active'.

Local field names of interest includes Balls Ground, derived from Middle English balle and telling us of 'the earthen boundary mark'.

Caversham

The place name was recorded in Domesday as Caueresham, which comes from 'the homestead of a man called Cafhere'.

Street names of note here include Briant's Avenue, Briant's Farm was owned by the Briant family for centuries and sold for £7,500 in 1890. George Champion was another local landowner, he died in 1826 and is commemorated by Champion Road. The family who gave their name to Crawshay Drive were at Caversham Park until 1920, while in the previous century the family in residence were the inspiration for Montague Street. Sir Rufane Donkin was a landholder around Donkin Hill in 1839. Hardy Close was cut in 1990, the 150th birthday of Thomas Hardy who was often associated with the village. Carlton Road took its name from the developers.

Waley's Place is situated close to where John Waley drowned in 1329. His was the first documented fatal accident in this parish and, as a result of the explanation, the first of what would today be said to be the coroner's report. Poor Waley drowned in Westbrook, although where he was found was hardly deep enough to be considered in any way dangerous. Thus it was deduced that he had been unseated by his horse and had fallen into the water and been knocked unconscious, although there was no outward sign of any such blow.

Chadlington

A name recorded in 1086 as Cedelintone, which comes from the Saxon. Here a personal name is followed by the elements ing-tun, giving 'the farmstead of the people of Ceadela'.

Local names within this parish include Shippenhull, which is derived from scipen-hyll and tells us this was 'cattle shed on or by the hill'. Barley Hill is a corruption of 'hill of the woodland clearing', with the later addition of 'hill'. Brookend, Greenend, and Millend are all exactly what they would seem to be, although the ende is a 'district', a small region named after the named feature.

Catsham Lane which crosses Catsham Bridge are the only remaining examples of a lost place name which has been suggested as being 'the river meadow frequented by cats'. Sometimes it is necessary to apply a little logical thinking to question a definition of a name, and Catsham is an example. The first element has always been said to be 'cat' although there are three very good reasons for questioning this being said to refer to feral domestic cats. Firstly the habitat, which the name tells us is subject to regular

flooding (at the very least) and as we all know cats loathe water. Secondly all cats, with the exception of lions, are by choice solitary animals and would be highly unlikely to congregate in great numbers. However, if the first two are wrong assumptions, we encounter the third problem. For the name to stick the cats must have been here for some time in great numbers. To attract the cats there must have been plenty of prey, to keep them here that food source must have been both prolific and inexhaustable - this can only have been rodents and if they were numerous enough to support a huge cat population, the place would have been infested to the point where the place would be named after the prey and not the predator. Hence the place name must surely be based on a personal name Cat (or perhaps Cate).

One pub here has what must be a unique name. The Tite Inn has stood here since at least the Middle Ages, although not always known by that name. It comes from Middle English to describe a natural underground spring which still bubbles up from beneath the ground and the crystal clear fresh water has been channelled away from the pub.

Chalgrove

Listed as Celgrave 1086, Chelgraue 1155, Cholgrave 1229, Challegraue 1246, this name comes from Old English cealc - graef and meaning 'chalk or limestone pit'. In later years the the ending became 'grove'.

Langley Hall was situated on 'the long woodland clearing' from Old English lang-leah. Rofford is recorded as Ropeford in Domesday and Repford in the late thirteenth century, being named from '(place at) Hroppa's ford'. Warpsgrove is an old name, Saxon in origin from Old English werpels-grafa and giving 'the bridge path through or by the grove'.

Field names include Calvert Leys, 'the woodland clearing frequented by wood pigeons'; The Flakes, a dialect term for a small hedge or hurdle; Pry Plot, features a general term for 'grass'; and Bacon Lane, named after Christiane Bakon who was here around 1270 and which was used for both the field and the lane running alongside it.

Charlbury

A name noted around AD 1000 as Ceorlingburh. This is yet another name of Old English beginnings and describes 'the fortified place associated with people of Ceorl', the elements here being ing-burh.

Pub names here include Ye Olde Three Horseshoes, the apparent age is a twentieth-century advertising gimmick added to a standard pub name which once spoke of a blacksmiths service being available. Another typical pub name is the Bull Inn, thought to have begun life as a religious reference to Catholicism in the form of a papal bull.

Around the parish we find Baywell Gate derived from 'Baega's stream'; Dustfield Farm really does refer to 'the dusty open land'; Hundley Road ran to or by 'Hunda's woodland clearing'; Rushey Bank is land above the 'the lake of the rushes'; Walcot was the 'cottages of the Britons' and a term which can still be seen as being akin to 'Welshmen'.

St Mary the Virgin, Charlbury.

Charlton on Otmoor

Recorded in 1086 as Cerlentone, in 1190 as Cherleton, in 1245 as Cherlton, and in 1428 as Chorlton the addition for this name is not seen before the twentieth century and was probably not required prior to this. Additions are there solely for distinction when two similarly named places are likely to be confused, normally because of their close proximity. Here there is no nearby Charlton or Chorlton, despite it being among the most common place names in the land and coming from ceorl - tun or 'the farmstead of the free peasants'. The most likely reason for the addition was it lay on a route where there was another place of a similar name, be it a part of the road or rail networks. However the thought of it being a public relations excercise cannot be entirely dismissed, for there can be no doubt that the modern name conveys a message of a quintessentially English village while the traditional name is simply a place name.

The addition itself comes from 'Otta's mor or fen', the term is applied specifically to low-lying ground by a river in the county, while Otta is likely the same person who gave his name to Oddington.

Chastleton

Listings of this name are many, including Ceastelton in 777, Cestitone in 1086, Chestelton in 1100, Cestretona in 1129, Cestrenet 1143, Chastelton 1246, and Casterton in 1346. This is a Saxon name and refers to a much earlier period of Chastleton's history as ceastel-tun, the 'farmstead of the prehistoric camp'. A name which shows there has been much confusion over the centuries, even by the Old English speakers, between ceastel 'prehistoric camp' and ceaster 'Roman fort'.

In the region we find minor place names such as Brookend House, a name telling us it was constructed on the small field which had a small stream running alongside it. Durham's Farm is not named from the northeast city but a former proprietor, Nathan Durham was living in a house called called Simmonds in 1789. A Symonds Meadow can still be found on this farm, while Hogg's Barn was named after the 1363 tenants of William and Henry Hogges of Eynsham.

Chazey Heath

A name with a quite fascinatingly different etymology. The heath element requires no explanation, indeed it is sometimes omitted from the place name altogether. The earliest record we have dates from 1476 as Chawses, which is undoubtedly a manorial name as the place had belonged to them since 1180 when it was under the control of Walter de Chauseia. It is thought this family name, and thus the family themselves, came from Cholsey in Berkshire. The original place name means 'Ceol's dry land in marsh (literally island)', but the transfer of the name makes the definition irrelevant.

Yet the lack of an original place name does reveal some information. Firstly the place would not have been settled before this, at least not recently, as it had no name prior to this. It may be argued that the new inhabitants replaced the existing name with their own. Yet place names are not coined by the inhabitants (to them it is simply 'home') but by the neighbours, hence no matter what the new landholders may have called it, the name given by the neighbours would prevail in the long term.

Checkendon

Domesday recorded this name as Cecadene in 1086, with later forms of Chakenden in 1175, Chacundene in 1395, and Chakesden in 1235, which comes from a Saxon personal name with the Old English denu, giving 'Ceacca's valley'. This personal name found in several places around the country, including the record of Ceacca wylles heafde from 1012 which refers to the boundaries of nearby Whitchurch and must be the same person or related individuals separated only by a maximum of two or three generations.

Local names here include Horsalls, which is probably 'Horsa's hollow' but the first element just may be hors which, together with holh, gives 'horse hollow' and a place frequently used when horses were travelling. Littlestoke Farm is named from a place name which existed well before the farm was laid out with boundary hedges. Indeed it is recorded in Domesday as simply Stoch, which comes from Old English stoc which has so many uses it is normally said to be 'special place'. This should not be considered as

in any way religious or mystical, it was simply a special place because it had a specific purpose and invariably that was agricultural. The addition of 'little' is not seen until 1618 to distinguish it from South Stoke, previously it was recorded as Stok Marmion which pointed to ownership by Geoffrey and Robert Marmion.

Rumerhedge Wood comes from ruh-mere-hecg, Old English telling us of 'the rough pool with a hedge'. Hammond's Wood is named after the family of John Hawman, who were here in 1331; Neal's Farm was inherited in 1606 by John Neel from his father, hence this family were here before this date; Wheeler's Wood remembers Richard Wheler who owned land here in 1564; Stockings Shaw is a Middle English name telling of 'the place cleared of stocks or tree stumps'.

Field names here include some interesting examples of local dialect terminology: Bud Pits tells of 'a region where yearling calves are found', bud being a dialect word for last year's cattle; Burge Grove Wood has burge, a local term for a bridge, telling us of 'the wood of the bridge by a grove'; Chesscroft features chess, a type of grass which is commonly found growing as a weed in a wheat crop, Bromus secalinus; The Hanging is derived from hangende, a Middle English description of sloping land; Withy Eyot is from withig - eyt 'the islet where willows grow'; with the term pightel a small parcel of land enclosed by a hedge seen with obvious attachments in Six Pightles and Parsons Pightle.

The Cherwell in winter.

Cherwell

A river name recorded in 681 as Ceruelle, in 864 as Cearwellan, in 904 as Cearwyllan, in 1005 as Cyrwylle, and in 1185 as Charewelle. The second element is undoubtedly Old English wella meaning simply 'spring or stream', which may be hinting that it was named such at its source. However the first element has defied all attempts to locate a possible origin, having no potentially similar elements found anywhere along its course. The most likely explanation is that it is the sole survivor from a former place name which is either lost or, more likely, has a different name and all traces of the earlier name have vanished.

Chesterton

An unremarkable place name which comes from the Old English ceaster - tun 'the farmstead by a Roman stronghold'. There are actually two places here, the names being recorded with the Latin addition as Magna Cestreton and Parva Cestertona in 1278 and 1227 respectively, and while the main name has lost its addition Little Chesterton has not.

Field names can be an easily overlooked source of information of the history of a place. Here we find Cow Pasture, Sheep Leys, Down Fields and One Crop Field - which tell us more than would be at first apparent. For example 'one crop' tells us there was a demand for this particular grain and also that the soil was capable of sustaining this crop year after year in order for the name to stick. Hence by looking at a place name we have a clue as to the economy of the region, based on one particular product; the annual climate, because it is likely the region's fertility was replenished annually in order to maintain volume and quality and the most likely answer is silt brought here by a flooding river; and the stability of life here, for this must have existed for some time in order for the names to still be found at least three centuries later.

Chimney

Listed in 1069 as Ceommanyg, here a personal name is followed by the element eg. This can be defined as 'Ceomma's place of the dry ground in the marsh' – literally said to be an island. Clearly the spelling of this place name has been influenced by the pronunciation.

Chinnor

Records of this name are found as Chennore 1086, Cennor 1180, Chinnora 1194, Chinnouere 1234, and Chynmor 1268. The name is from 'Ceonna's sloping land', the suffix here Old English ora.

Emmington is a local name referring to 'Eama's farmstead'; Henton takes its name from '(the place) at the high farmstead'; while Hempton Wainhill has a different form

of the previous name with a personal name and halh and giving 'Willa's corner of land at the high farmstead'. Oakley is a common name and speaks of 'the woodland clearing of or by the oak trees'. Red Lane is an unusual name, it would normally be accepted that it runs through red clay soil, yet that is not found here. It seems it is a transferred name, brought here because of common ownership. Hedgerley Wood is associated with the family of Hugh Eggerley of Aston Rowant. Venus Wood is named after a Vernice who was around some time before 1840, it is today used as a Christian name for girls but at this time was a surname; Kuneger is a corrupted coneygree 'rabbit warren'; Menley Close and Menley Piece are named after Victor de Menle, here in 1270 and whose name itself refers to 'common pasture'; Several is a field name referring to long-term private ownership, rather than common land and nearly always situated close by such common land; Breach tells us this was land newly claimed for cultivation; Souldern is the 'south valley'; Summerleys 'the summer pasture'; Lammas is a field name which was rented for cultivation until Lammas-tide on August 1st, at which time it became common pasturage until the next growing season.

Chipping Norton

Norton is one of those common elements found so often as to merit a second defining element. The basic name comes from Old English north - tun 'the northern farmstead' and is found as Nortone in 1086, which was to become Chepingnorthona by 1224. Unlike so many others, the addition is not a reference to the lords of the manor but is another Saxon name. From ceping this refers to a 'market', clearly a very regular and important venue in this area to have become a part of the place name.

The origins of the street names here have a story to tell too. Ackerman Road was named to honour the tireless charity work of Cyril Ackerman. Brassey Close recalled the former MP and Mayor Albert Brassey, who lived at Heythrop House. Cornish Road marked the work of Henry Cornish, a wealthy businessman and benefactor. Hitchman Drive marks the industry of James Hitchman, who founded the brewery in the eighteenth century. Rowell Way marks the family who were both ironmongers and engineering contractors here until as recently as 1965. John Ward ran a successful carrier business, with lucrative ties to collect and deliver to Birmingham, from his premises which stood where Ward's Road does today. However Glover's Close remembers that the town once had an important gloving industry, and is not a family name.

Public houses are an integral part of a community, reflecting the people and the history. The Albion Tavern features a poetic name for Briton, as much a patriotic name as that of the Crown and Cushion Hotel, a royal reference. With so many 'crown' names found across the land, alternatives are always being sought. To depict the simple image of the crown resting upon a cushion is a clever solution.

Other names found around the parish include Coneygree Terrace which tells us there was previously a 'rabbit warren' here; The Cleeves is a name used in a plural sense to describe the clif or steep bank of the river; Primsdown Farm comes from a place name meaning 'Praen's hill'; while Priory Farm occupies the site of the former St John's Priory.

Chislehampton

The earliest record of this name is as Hentone in Domesday. This comes from the Old English heah-tun 'the high farmstead'. Just sixty years later the name appears as Chiselentona, the extra element from cisel meaning 'gravel'.

The two records are not separated by a great length of time, indeed they could almost be considered to be contemporary as they are within a single lifespan. As Domesday's accuracy in the spelling of proper names is notoriously unreliable, this is likely to be an example of a error in the great tome. Alternatively this may be an indication that there were either two small settlements close to each other which eventually became one.

The D'Oyley family had several holdings in Oxfordshire, notably those named from them in Stonor, and also here in the form of D'Oyley's Farm. Gotham Farm began life as 'the homestead where goats were kept', Marylands Farm is fairly modern and a remoteness name, suggesting it was the furthest flung area of Chislehampton.

Cholsey

Recorded in 895 as Ceolesig and as Celsei in 1086, this name features a Saxon personal name followed by the element ieg. This tells us this was 'Ceol's island', in this case the 'island should be seen to be dry ground in a region which was predominantly wetland, a natural raised area.

Despite our first thoughts the reference is not to the planet Venus, also known as the Evening Star, but to the Morning Star being a steam locomotive produced in 1906. Part of a series of 4-4-2, this four cylinder GWR locomotive is awaiting restoration.

Christmas Common

A name which must still bring a smile to the faces of those not familiar with the area. While the name is a fairly recent one, not recorded prior to the early seventeenth century, there was no humour intended in the name of this place. In the early eighteenth century we find the name as Christmas Green, while in 1617 is said to be Christmas Coppice. This latter record likely tells us the place was comprised mostly of holly trees which have long been associated with the festive season.

Churchill

Although the earliest record of this name comes from thousand-year-old Domesday, where it is seen as Cercelle, the name itself is in part much older. The two elements here come from two different languages – Celtic crug and Old English hyll - although both mean the same thing and thus should be defined as 'hill, hill'. Although this may seem an unnecessary duplication, we should remember the Saxons would have not have understood the meaning of the Celtic term. To them it would simply have been a 'hill named Crug'.

Standbow Bridge is a name taken from stan-boga or 'the stone arch', from which we can also glean that the arched bridge across the stream was not something people had seen being built before as this is certainly not of Roman construction and the technology behind the arch would have been forgotten. Conduit Farm had a purpose built drainage ditch or conduit to make the land more suitable for agriculture.

A fingerpost of the Christmas Common.

Clanfield

Listed as Chenefelde 1086, Clenefeld 1196, Clanefeld 1204, Kanefeld 1227, Clenesfelde 1275, and Clanfyld 1380, all of which come from Old English claene-feld which literally describes 'the clean field' and refers to a region which is free from weeds, tree saplings, stones, etc.

Locally we find names such as Edgerly Farm takes its name from an early Saxon place name of 'Ecgheard's island'; and the delightfully named Chestlion Farm which has no wonderfully ornate beginnings, but is simply a corrupted family name – the de Chastilon family had property here by 1278.

Claydon

A name found as Cleindona in 1109, Claydon as early as 1215, and as Cheyndon in 1268. This undoubtedly comes from '(the place at) the clayey hill'. Within the parish is also the name of Clattercote which began life as 'the cottages by the clatter'. A clatter is an old dialect term talking of 'noisy debris, loosely tumbling stones'.

Clanfield village sign.

Clifton Hampden

This name has a rather unusual etymology. Found as Cliftona in 1146 and Clypton in 1252, this comes from the Old English clif-tun 'the farmstead on or by a bank of land'. The addition is a puzzle, even though the basic name is a common one. There is no other 'Clifton' nearby and the addition seems superfluous, furthermore there is no record of a family named Hampden ever being associated with the place and it does not appear in any record at all before a map of 1836. Various suggestions have been proposed as to why the addition suddenly appears, however the most likely is that it is simply an error.

Burcot probably derives its name from 'Bryda's cottages', while Fullamoor Farm tells us this was 'the foul or dirty pool' before the farm existed. Chesil Pitts gets its name from ceosel meaning 'gravel'; with Hen and Chickens, when used as a field name, refers to at least eleven different kinds of wild plant and not the world's most numerous bird.

The Chequers Inn is a pub name which is among the oldest known going back to Roman times. It refers to the chequer board, hung outside as a sign this was an establishment where the game could be played within. Later the same sign was used to show the inn was the place of a moneylender, it is the basis for the term 'exchequer'. The Plough Inn is a popular name for it does not require an artistic sign, an old plough hung up outside will suffice.

Coldron Brook

A name which is derived from a minor place name, recorded as Colthurne in 1356 but no longer in use. From an Old English suffix of hyrne this refers to 'corner of land where colts are seen', and furthermore suggests that this was probably an early stud farm for working horses.

Coldwell Brook

First seen in 1591 as Cawdell Brook, this name means what is says 'the cold spring' to which the later 'brook' was added. It comes from an early Old Anglian cald-welle, so the addition must have been around the time of that earliest record in the sixteenth century.

Colwell Brook

Despite the similarity with the previous name, the first element has a quite different origin. However the suffix of wella has identical origins and the addition of 'brook' is again quite late and a duplication. The first part comes from Old English col meaning 'charcoal' and telling that there was a regular charcoal burner working here.

Combe

There are over a dozen reasonably sized settlements with this name throughout England, of which this is the only example not to have a second element to give it a unique identity. Records of this name are restricted to that of Domesday, as Cumbe, and there is no doubt the Old English origin is cumb, itself normally seen as a suffix and still used in some places to describe 'a valley'.

Minor names of this parish include Combe Cliff, the region where the was a vertical river bank. Notoaks certainly comes from the Old English nattock, however this term has never been understood even though it is used in several places throughout England. The small regions may have one thing in common, that is being areas which stand a little higher than the surrounding land although it has not helped in defining it.

The origins of name of the Cock Inn are uncertain. A standard pub name for centuries, most often found with a second element, it once told customers it was a venue for cock fighting officially banned in England and Wales in 1835. However the popularity of the name received a boost from the seventeenth century when it was also used to advertise cock-ale, the recipe being a mixture of the jelly and finely chopped meat of a boiled cock with ale and vegetables.

Cornbury Park

Found in Domesday as Corneberie, in 1223 as Acornebir, and in 1301 as Cornbury this name speaks of 'the earthwork frequented by herons'. The addition of Park was not seen until the Middle Ages, when parke told of 'an enclosed estate for keeping the animals of the hunt', and fundamentally a deer park.

This district contains an unusual element, seen in several place names such as Tower Light, Witney Light, Hazel Light, and Shamspires Light all refer to 'a long footpath by the side of a wood'. There is also a Towerlight Gate in the park which, along with

Shampsires, refer to buildings of the estate; Witney lay in that general direction, and Hazel trees were once very commonly found in England.

Cornwell

A name found in the eleventh century as Cornewelle, seen to be derived from the Old English elements corn-wella. This tells us of a '(place at) the stream frequented by cranes or herons'. As many streams would have been visited by such large birds, the numbers here must have been noticably greater than normal and probably permanent.

Cote

Recorded as la Cote in 1203, the name means quite simply 'cottage or cottages'.

Cothill

First found in 1783 exactly as it is today. As with the previous name the meaning is quite simple in 'the cottage(s) on the hill'.

Cottisford

Early forms of this name show this to be from Old English for 'Cott's ford', a name which was coined before the time of Domesday.

Minor names here include Coneygre Farm, named for its rabbit warrens and also seen in the field name of Great Warren, and Juniper Hill which was recorded as having abundant examples of Juniperus Communis or Common Juniper in 1754 and a few stunted examples can still be seen today.

Cowley

There are four significant settlements in the southern half of England with this name, interestingly all four have different meanings. Here the name was recorded in 1004 as Couelea and in 1086 as Covelie, which points to a Saxon name from '(the place at) the clearing of a man called Cofa or Cufa'.

One street in Cowley, Sheldon Way, is named after the Sheldonian Theatre at Oxford.

Pubs in Cowley include the Nelson, named after one of the nation's greatest heroes Horation Nelson, 1st Viscount Nelson (1758-1805). His naval career began at the age of 12 and ten years later he was captaining his own vessel. The next 25 years were largely uneventful, until conflicts with the French brought him fame at Aboukir in 1798, he destroyed the Danes at Copenhagen in 1801, and the combined French and Spanish fleets at Traflagar.

Local history is also recorded. The name of the Bullnose Morris, the unofficial name given to a vehicle produced here from 1913. Forty years after production of this model

had ended, in 1967, the public house was opened. Finally the Original Swan, the bird makes an attractive sign and hence a popular one. As part of the battle to produce a unique name we see additions and, while there is no sign of another Swan here today, the proprietors saw a need to suggest otherwise.

A local place name is that of Rose Hill, a recent addition first seen in 1853, and probably given by locals to describe a region where wild roses proliferated. There is also the local name of Temple Cowley, the addition differentiates from Cowley while also telling us it was land given to the Knights Templar in 1139. Field names can often provide information on what was happening in an area on a day-to-day basis, Bullingdon Slad is 'the valley of the bulls, valley' where both denu and slaed are used to tell of the valley, hence the definition. Lower Durvall shows a corruption of Derefolde (1210), which comes from Old English deor - fald or 'the enclosure for deer'. Compass Field is a corruption of 'compass field', here since the middle of the eighteenth century, while One Pound Lane marks where the 'one of the pounds for stray animals' was situated, and not a turnpike toll charge as has been suggested.

Crawley

With records of Croule 1214, Craule 1227, and Crawle in 1285, this common place name is derived from Old English crawe-wudu 'the wood of the crows'.

Local names include Blindwell Wood, telling of 'the spring hidden by vegetation'; Breach Barn stand on 'the land newly taken for cultivation', presumably when the first barn was erected here; Chasewood Farm is located near the chase or 'hunting grounds'; The Linsh is a rather unusual form of hlinc or 'the bank of rising ground'; and Showell's Spring refers to 'the shallow spring or stream'.

Cropredy

This name is recorded as Cropelie in 1086 and Croprithi in 1275. As with several other names, the first element here has two equally plausible origins, both preceding the Old English rithing. Either this is a personal name and thus '(place at) the stream of a man named Croppa', or perhaps the first element is cropp and thus '(place at) the stream near a hill'. Without further examples the doubts will remain.

One of the local pubs here is the Brasenose Arms. The name is taken from the college at Oxford which held a large amount of the village from the early sixteenth century. Built on the site of Brasenose Hall, the name is thought to have originated from (of all things) a door knocker. The 'brazen nose' was a bronze knocker in the shape of a nose, evidenced by that very thing hanging in the main hall of the college which it is said was taken from the main door of the former hall.

Crowell

Records of this name are found as Clawelle 1086, Crawella 1163, Crauwell 1246, and as the modern form as early as 1268. This comes from an Old English crawe-wielle and tells us of 'the spring or stream where crows abound'.

Honey Furlong always refers to a field with 'sticky soil'; Nag Butts is the strip of land at the end of the field ridges, and running at right angles to same, where a horse would have been tethered.

Crowmarsh Gifford

In 1086 the name is simply Cravmares but by 1316 Cromershe Gifford. This addition is a manorial one, a reference to a man called Gifard who held the manor at the time of the Domesday survey. As the majority of manorial names are added for distinction, we must assume this was not the case here as it seems it was the only place so named. Crowmarsh means exactly what it says 'the marsh where crows abound', a name from Old English crawe-mersc.

Minor names here include Greyhone Wood which was the site of 'the grey stone' and likely a boundary marker; and Howbery Farm comes from hoh-burh 'the manor by the spur of land'.

The local pub is the Bell, which reminds us of the long association between the village pub and the parish church.

Cuddesdon

A name which means '(the place at) Cuthen's hill'. The suffix here is Old English dun, as can be seen from the early records of Cuthenesdune in 956 and Codesdone in 1086. Cuddesdon Brook is named from the place, although in 1278 it is named as Cumbe Brok, itself named after the Coombe Wood where it rises and a name which means simply 'grove'.

Coombe Wood takes its name from cumb, Old English telling of a 'valley'. The term slay is used to describe 'a lane cut through broom to allow the passage of a farm cart for collection purposes' or in other areas it can mean simply 'slope'. There is no geographical split between the two, they both seem to be equally distributed and as commonly used. However the latter 'slope' is favoured here simply because there are so many examples, such as: Slay Barn, Slay Farm, Slays Plantation, Cozenslays Plantation, Upper Slays, Middle Slays Bottom, and Slays Pond.

An English village without its cricket team is seemingly incomplete. In Cuddesdon the local team is commemorated in the name of the local pub. It is not hard to imagine the scene appearing on the sign of the Bat & Ball.

Culham

The earliest record of this name is from 821 when it is found as Culanhom. This is a Saxon place name featuring the element hamm and giving us '(place at) the river meadow of a man called Cula'.

Locally we find Andersey Island, named from the dedication of St Andrew's Church. Not, as was suggested the surname Anderson, nor the contrived suggestion of 'undersea island' – whilst this region was undoubtedly under the sea millions

of years ago, as archaeological evidence proves, nobody was around to witness it and thus name it. The name of Rye Farm also refers to this region, being 'at the island', and Otney comes from 'the outlying island', although perhaps it should be clarified as meaning 'the dry land among the marsh' rather than an island in the normal sense.

Cumnor

Old English ora is an uncommon suffix meaning 'hill slope'. Although the Saxon settlement would invariably be on the slope the name often simply suggests it is on or near the hill. Here the name refers to '(the place) on the slope of a man called Cuma' and was recorded as Cumanoran in 931 and Comenore in 1086. As if it was named simply to add weight to the definition, at the top of that same slope less than a mile away is the small settlement known as Cumnor Hill.

Two pub names of note here. Firstly the Vine was an early advertising name, once much more common than it is today. In regions where grapes are grown, increasingly more common despite what we might think, the name refers to a local vineyard. However the more common beginning is heraldic, a reference to the Worshipful Company of Distillers founded in 1638. There is also the Bear & Ragged Staff, another heraldic symbol originally a reference to Richard Nevil, Earl of Warwick (1428-71), but today symbolising the neighbouring county of Warwickshire.

Curbridge

A name found as Crydan brigce 956, Crudebrigg 1200, Credebrigge 1209, Cradebruge 1316, and Curbrigge in 1517, all of which show the origins to be '(the place at) Creoda's bridge'.

Within the boundaries of the parish we find Burwell Farm which has two possible origins, either burh - wiella which tells of the 'stream by a fortified place', or beorg - wiella giving a 'stream by a barrow'. Similarly Caswell House also has two potential origins, which is either 'Cafhere's stream' or this is caerse-wielle 'cress stream'. Apley Barn takes its name from Appley Piece and Appley Meadow, all describing a region where orchards were planted or possibly naturally occuring. The name of Coneygar Pond is a somewhat corrupted term for 'a rabbit warren', which would have been uphill from here and probably existed well before the pond.

The Lord Kitchener Inn is a face all have seen, even though they may not have known the name of the individual. His was the famous face on the recruitment poster for First World War soldiers where he was pointing at the observer and stating that "Your country needs you!", an image which has been copied many times. Horatio Herbert Kitchener, 1st Lord Kitchener (1850-1916) was a field marshal and statesman who led the victorious combined forces of Britain and Egypt against the Sudan in 1896-8, he later fought and deafeated the Boers in South Africa. On his way to Russia for talks with Tsar Nicholas II in 1916 he drowned when his ship was sunk by the enemy.

Lord Kitchener at Curbridge.

Cutteslowe

In 1004 it was Cuoueshlaye, by the time of Domesday Codeslawe, and in 1122 Cudeslawe. This suffix comes from the Old English hlaw and telling us this was 'Cupen's burial mound'. A somewhat misleading name for it could be thought that this gentleman was buried here, however the individual was a Saxon while the burial mound would likely have dated from at least five hundred years earlier prior to the arrival of the Romans. It is simply that the Saxon settlement was created on or near the site of the ancient burial mound.

Cuttle Brook

A name recorded as Cuttelehulle in 1270, le Cuttelmille in 1290, and Cottelemulle in 1303. There are small rivers of this name recorded in Thame and Banbury, while there are also records in Germany of Cuttelbeke, Cutelbecke, and Kutelbeke between the eleventh and the thirteenth centuries. Not only is there a remarkable similarity between the pronunciation of these names but the first element also describes the rivers quite well as 'intermittent', that is they all had a tendency to run dry.

Cuxham

In 995 this place appears as Cuces hamm and by 1086 as Cuchesham. The late tenth century record is almost perfect Old English in describing 'Cuc's river meadow'.

The name of Easington is recorded as Esidone in 1086, Esindon in 1200, Esyngdone in 1285, and Heysindon in 1300. From the Old English suffix dun, this is 'Esa's hill' with the addition of -ing- showing confusion with tun. Cut Mill is a name found all over the land, every time it tells us that a channel was dug in order to bring the water to the optimum delivery point in order to turn the mill wheel. Greenwich Close is a field name which has no connection to the world's time zones, but comes from 'the green enclosures'. The Plash is a regional word for 'place with a pool'. Sour Ale is a piece of land described as 'sour' and suggesting 'cold and wet'. As a result the naming of Sweet Ale was solely to contrast with the other and has no etymological value; and Stir Furlong is a 'tail-like area of land', seemingly attached to another field.

Ever since Homo sapiens first looked toward the heavens and wondered what he was really seeing, the moon has been a source of inspiration and wonder. Innkeepers were quick to take advantage of the romantic imagery, especially as it was such a simple image to reproduce. Interestingly it is probably more easily recognised when incomplete, as is the case with the Half Moon.

Chapter Four

D

Danes Brook

A name which is found in a document dating from 1294 as Denebroke. This undoubtedly comes from Old English denu-broc and meaning 'the brook in a valley'.

Deddington's church.

Deddington Hall.
 The Crown and Tuns, Deddington.

Deddington

A name of Saxon beginnings, a personal name followed by ing-tun and describing 'the farmstead of Daeda's people'. The name is recorded as Daedintun in 1050 and Dadintone in 1086.

Within the parish we find the names of Clifton, the 'farmstead on or by the steep river banks'; Hempton, 'the place at the high farmstead'; Ilbury Farm, 'the yellow fort' and a reference to the prehistoric encampment constructed near a ridge of yellow ironstone; The Fishers is a number of small pools or stews which housed food fish for the nearby castle; while The Windmill is a misnomer and should refer to 'the western (water) mill'.

Local inns here include the Crown & Tuns, which incorporates two popular forms of pub imagery, the Crown a reference to support for the monarchy, and the Tun a large cask for wines and beers with a capacity of over 250 gallons. The Unicorn Inn features a symbol popular in heraldry and mythology. Its single horn has forever been thought to have magical properties, while the fabled animal could represent Scotland, chandlers, goldsmiths or apothecaries.

Denton

Records of this name begin with the name in the present form in 1122. There are later varying spellings from the thirteenth century as Dendone, Dinton, and Dyntone, all of which suggest this is from Old English denu - tun or 'the farmstead in a valley'. Here is also the place name of Chippinghurst, listed as Cibbaherste in 1086, Chibenhurst in 1122, Cimbehirsta in 1140, Chibbeherst in 1194, and Chipenhurst in 1200, the meaning and evolution of this name is clear. This began life as 'Cibba's wooded hill', the personal name being a variation on the popular name Ceobba. Later this is used as cieping and changing the meaning to 'market' which, although undoubtedly accurately describing the place, was not the original meaning. This clearly shows the necessity for finding as many early forms as possible.

Field names here include the unusual Aloord which is seen around 1300 as Aldeford and can only be 'the old ford'. Parting Close is a name used for two reasons – either this is a border field, or alternatively the field was divided into two for different uses or crops. Nine Steeches is said to show the Old English stiche, the meaning of this word has never been adequately defined. Indeed it seems to have different meanings in the area of the Angles (ie East Anglia) as 'a ridge or balk of land', while around Wiltshire the term seems 'stitch' although no connection has been made to a field name. Oxfordshire, being between the two, could be said to have connections to either. However the most likely explanation is that of 'the ridges' for there is a numerical value attached to it.

Didcot

The earliest mention of this place dates from a document of 1206 when it is given as Dudecota. Here the suffix is the Old English cot and giving 'Dudda's cottages'.

Pub names here have examples from most of the areas from which landlords have drawn in the endless search for a unique and memorable name. The rural scene is a popular theme, seen here in the Horse & Harrow and the Oak at Didcot. Found in the arms of most noble families the ursine image is seen in the Bear Inn and the Bear At Home. Similarly there is an heraldic origin for both the Wallingford Arms and the Queens Arms.

Dorchester

Archaeological evidence shows this to be one of the oldest settlements in the county and the origins of the name would confirm this. While Domesday gives this as Dorchecestre, the earliest record dates from 731 as Dorciccaestrae. The suffix here is Old English caester, a term used to describe a Roman stronghold. The first element proves much more difficult to define. Experience in the evolution of names and the languages of these isles means that, while the meaning is unknown, the word involved is not. Thus this would be 'the Roman stronghold called Dorcic', which would have been the name of the place prior to the arrival of the great empire in the first century AD. It is not a tribal name, indeed it does not seem to be a proper noun, which probably means the word has been so corrupted as to be unrecognisable.

Minor place names here include Overy which is across the river from the main body of Dorchester, as is reflected in the name which tells us it is 'over the river'. Queensford Mill takes its name from the Queensford, a name derived from Old

English cwene-ford the word now suggesting the most important woman but in historical terms it referred to any woman. Thus the mill was situated at 'the woman's ford' meaning 'the ford tended by a woman'. A name which today may not be the first choice for a road developed on Wally Corner simply tells us this was 'the well or spring at the corner of land'. Other field names include Chisselton Furrows, nothing to do with either stone tools or dairy produce but 'gravelly soils'; and the local term used for the slender straw and giving the unusual name of Wimblestraw Furlong.

The Fleur-de-Lys Inn is named after the symbol which originally was the heraldic emblem for France. When Edward III declared himself 'King of France' he incorporated the image into his own coat of arms and, as a result, is a general reference to royalty.

Drayton

There are two places so named in Oxfordshire, one near Banbury the other near Abingdon. This name is found many times throughout England, indeed the major surprise here is that neither of the places have acquired a second distinctive element as most Draytons have elsewhere. That the name is so common is hardly surprising considering the meaning is 'farmstead by or near a portage'. A portage is a term rarely in use today, it refers to a place where something is regularly dragged – such as loads to and from a landing stage on a river, or where boats are dragged around an obstruction in a river, or even between two rivers to reduce a journey.

Both were listed as Draitone in Domesday, while there is an earlier record of the Abingdon version as Draitune in 958.

Pubs at these places include the Wheatsheaf Inn, a name popular for many years because of its simple imagery and association with the harvest. However the most popular pub name in the land is the Red Lion, with over six hundred examples, it is used to represent John of Gaunt and Scotland.

Drayton St Leonard

As with the previous name, this is from 'the farmstead on or near a portage'. To distinguish it from the other the name of the church was added. Waterside House was named from 'the watery dale', and appropriately so for this region was often flooded by the Thames. Cockle Furlong is a reference to various plant life, not marine invertebrates; Honey Furlong told us that the soil here was sticky; Lammas Close would have been cultivated up to August 1st (Lammas-tide) and became common land for the rest of the year; Pound Close marks the site where stray animals were impounded awaiting collection by the owner on payment of the fine.

Dry Sandford

A place name that virtually speaks for itself, although the '(place at) the sandy ford' is not exactly dry but seasonally wet. The place name has existed since Saxon times and is recorded as Sandforda in 811, Sandford in 821, and Sandeford in 1167.

Ducklington

Despite the modern form this has nothing to do with young ducks, indeed the suffix is also an error for this does not come from tun. This name is recorded as Duclingdune in 958, Duceling dune in 1044, Duklind 1122, Duclindona 1151, Dokelind 1176, Duglintona 1210, Dogelinthone 1270, and Dokelingtone in 1309. As we can see the suffix here is dun and gives a meaning of 'the hill of the family or followers of Ducel'.

Barleypark Farm takes its name from 'Beorna's woodland clearing'; Coursehill Farm comes from 'Cuthred's hill'; Gill Mill Farm is a corruption of Guilden Mill, used in a place name sense to speak of '(a mill by) the rich land'; The Moors is named from the family of Richard de Mora, who received 25 acres in 1218. The name of Claywell Farm is historically 'the eastern open land' from east-weald, yet somehow both elements have been changed to become claeg-wielle, however there seems no logical reason for it either deliberately or erroneously.

Dunsden Green

In the eleventh century the name is recorded as Dunesdene and it was not until the end of the sixteenth century that we find the addition in Donsden grene. The name originates from the Saxon, a personal name followed by denu giving 'the valley of a man called Dynne' with the later addition of grene referring to the 'village green'.

One local name tells a history in defining it. Playhatch is not seen until 1603 and, other than it being two words, in its modern form. This would have been where the locals would have held their village sports meetings, probably an annual event akin to the modern village fête.

Duns Tew

Here is a name listed as simply Tiwan, Tewe and Teowe in the eleventh century, which by 1210 had become Denestiua. There are two other places, Great Tew and Little Tew, which share the basic origin of Old English tiewe telling us this was '(the place at) the row or ridge of land'. The addition is manorial, a reference to the ownership by a man called Dunn.

*Duns Tew, winners of the Marlborough Trophy 2007 for the Best Kept Village in
Oxfordshire with a population of under 700.*

Chapter Five

E

East Challow

The name comes from the Old English to describe 'the tumulus of a man called Ceawa', with the addition to distinguish it from West Challow which was undoubtedly named after the same person.

Eaton

A very common place name for obvious reasons considering its meaning of 'the farmstead by the river'. This comes from the Old English ea-tun and is listed as Eatun in the ninth century and Eltune in 1086.

The local inn is another name which tells us of the long association between the village pub and the parish church. Here the Eight Bells refers to the peal which called the faithful to prayer.

Elsfield

A name recorded over the centuries as Esefeld 1086, Elsefeld 1123, Helsefeld 1124, Elshfyld 1232, Eldesfeld 1246, Elesfeld 1285, Ellefeld 1316, and Elsfeld 1335, there can be no doubt this is from 'Elesa's open land'. Sescut Farm takes its name from an area 'the cottages by the south elder tree', and which also gave its name to Sescut Mill. Lyme Hill takes its name from a tree, not the lime but the elm; while Pennywell Wood took its name in turn from the Penniwell, a spring where people visited to leave an offering, although it does seem a penny would have been a little extravagant in the early eighteenth century.

St Thomas of Canterbury, Elsfield.

Enstone

The Domesday entry of Henestan is the only early record found to date. Here is a personal name with Old English stan and giving us 'the boundary stone of a man called Enna'. Such stones were commonly used to show the parish boundaries at a time when no artificial hedgerows existed to provide a visible line in the landscape. Therefore where natural boundaries, such as rivers and stark topographical features, were unavailable large stones marked the extent of the settlement. These stones often stood for centuries and it is not unusual to find them becoming the focal point for religious rites.

Around this parish we find names such as Church Enstone, named for obvious reasons, while Neat Enstone has a first element meaning 'cattle'. Box Wood really did have a good number of box trees. Broadstone Plantation and Broadstonehill have a common origin in either 'Brada's stone' or 'broad stone', and refer to a monolith some 600 metres away from the place. Chalford takes its name from 'the chalk ford'; Cleveley is 'the woodland clearing on a bank'; Gagingwell is thought to be 'the kinsman's spring or stream'; Hoar Stone tells us of a 'grey stone' and probably a marker; Lidstone takes its name from 'Leodwine's stone'; Radford is probably not 'the red ford' for early examples would suggest rad or 'the ford which can be ridden across on horseback'.

Rural imagery, particularly when there is a farming association, is a popular theme when naming a pub. Whenever possible landlords would use real objects on the sign, it was cheaper than paying for a painter talented enough to reproduce a recognisable image and it would be likely to last much longer. This was particularly true when the objects were flat, such as a horsehoe, a malt shovel or the Harrow used to till the ploughed field.

E

Epwell

Recorded as Eoppan wyllan in 956, Epewella in 1185, Uppewelle in 1213, Ippewelle in 1260, Yppewelle in 1300, and Eppwell in 1537, this name comes from the Old English wielle and refers to 'Eoppa's spring'.

The local inn is the Chandlers Arms, a name which tells of the association of an early owner or innkeeper with candle making.

Evenlode (River)

This river takes its name from the village of Evenlode in Gloucestershire and means 'water course of a man called Eowla'. The old name of the river was Bladene 1005 or Bladene 1363, thought to be a British or Celtic river name but the etymology is uncertain.

Ewelme

The name is recorded as Auuilme in 1086, a Saxon name derived from a single word aewelm. This is one of the place names which the author finds the most interesting, it tells more than just the meaning, it tells something of the place when it was first settled. The name means '(the place) at the source of the river'. It is easy to envisage how the spring bubbling to the surface, bringing fresh water into a pool which spilled over and trickled downhill to form the infant stream. Furthermore it would offer the perfect source of clean and fresh water for the settlement which would have grown around it. Thus defining a place name has provided us with an image of the early life of Ewelme.

Grindon Lane is named after 'the green hill' to where it leads. Huntingland refers to a royal hunting stand, a place where the huntsman could obtain refreshment when hunting the area in and around Wychwood Forest. To find the origins of Cottesmore Farm look no further than the local church at neighbouring Brightwell Baldwin, where there is a monument to John Cottesmore, a former lord of this manor and who brought the name from the village of that name. Similarly Tidmarsh Lane does not run to Tidmarsh in Berkshire, but would have been brought here as a family name from that same place.

America Field is a remoteness name attached to the farthest corner of a place; Castar Furlong is 'the place of the cottages' and features the element stow which is often said to have religious connections and may suggest a clergyman lived here at some time; Kitchens Hedge tells us it was used solely for domestic purposes and probably for herbs and similar culinary additions; Thatchams Piece described 'the water meadow where reeds were cut for thatching'; and Peppard Mead was land owned by the same family who gave their name to Rotherfield Peppard.

The local inn here is the Shepherds Hut, a clear reminder that we are in the sheep country of the Cotswolds. What began as one of the earliest animals to be domesticated by man, turned to a massive industry in the Middle Ages and formed the basis for the wealth of the nation culminating in the British Empire stretching to all parts of the globe.

Eye

For those unaware, this really is one place. The name of Eye is from Old English e.g. describing 'an island' and referring to drier ground in an area of wetter land.

Minor names can tell us something of the history of a place. For example the Bishop of Salisbury owned the land here at the time of Domesday, which is marked by the name of Bishopsland Farm; Hag Pits is a name found four times in Oxfordshire, all meaning 'the pits where peat is cut'; Hampstead Farm tells us it was 'the homestead'; Reddish Farm tells us this was a place where the clayey soil had a particular colour in 'the red ditch'. Botany Bay is a remote name, speaking of the farthest corner of the place; Drift Road and Drift Way mark the routes taken by drovers of livestock; Herland Close is from hyrne-land or 'the corner of land'; Penny Field and Penny Meadow are names speaking of the nominal rent which was paid to work this land; both Roach Field and Hither Roach tell this was 'where hunting dogs are kennelled' and probably bred; while Stroods comes from strod, an Old English term referring to 'the marshy land overgrown with brushwood'.

Eynsham

While Domesday records this place as Eglesham in 1086, it is the earlier record from 864 as Egenes homme which provides the clues to solving the question of its origins. Here the Old English hamm or ham follows a personal name and produces 'Aegen's place at the river meadow' or 'Aegen's homestead' respectively.

The Chilmore Bridge crosses the Chil Brook, the stream name derived from Old English ceole meaning 'gully'. Derrymerrys Barn has been suggested is a corruption of an earlier field name here, that of Ave Maria Close where there was supposedly a shrine to the Virgin Mary. Foxley Farm was based where 'the woodland clearing of the fox holes' had existed for centuries. Monk's Wood has no known connection to a holding by the church, and therefore is probably the site of an individual monk's retreat or shelter. The Thrift is simply 'the wood'; Blindwell Farm is named after 'the spring overgrown by vegetation'; Twelve Acre Farm would have told you its purported size but would undoubtedly have been understated in the hope of misleading the tax collector.

Alma Place is a street name which has probably been confused with the Battle of Alma, an engagement from the Crimean War used for several names in the land, particularly public houses. However the real origin here is much earlier than the nineteenth century, it is recorded as Almery Close in 1545 and would refer to the place where Almoners lived and/or worked. Bartholomew Close is named after Bartholomew School, Wasties Lane after David Wastie, a long serving member of the parish council. Being cut in the same year as the 300th anniversary of the birth of Shakespeare, gave the theme of the Bard of Stratford for Shakespeare Road, Falstaff Close and Duncan Close. While Father John Lopes, a local clergyman, suggested the most contrived street name in Eynsham and possibly in the entire county. The land at Pelican Place was owned by Corpus Christi College who, we are reliably informed, have a statue of a pelican in the quadrangle of the college and hence the name.

Locals enjoy their favourite tipple in places such as the Jolly Sportsman, the addition of the adverb is a common method of conveying a pleasant and welcoming atmosphere

awaits within. The Newlands Inn is taken from a developer's name given for their work here, however the signwriter was far more imaginative. Look up to see two astronauts as they begin to explore a new world, the craft which conveyed them stands in the background with a crescent moon above them in the heavens.

Corpus Christi, Pelican, taken for a street name in Eynsham.

Chapter Six

F

Faringdon

In 971 this was recorded as Faerndunae and a century later as Ferendone. This name comes from Old English fearn - dun, telling us this place began life as '(the place at) the woodland clearing where the ferns abound'.

Two of the most popular subjects for pub names are seen here. In a predominantly rural location it is a good idea to reflect such, although the first Woodman Inn was probably run by someone who previously tended the forests. It is also a good idea to please the nobility, and none rank higher than the King & Queen.

The only way to welcome visitors to Faringdon.

F

Farmoor

As a place name Farmoor has had a somewhat unusual history. Historically this was a tything of Stroud in Gloucestershire, a Saxon administrative unit of indeterminate area for it relied almost more on productivity than physical size. The area was settled by 500 BC, archaeological evidence uncovered in the form of wattle and daub houses, a midden and iron working on a small scale. This dig was carried out as a precursor to the damming of the region to produce what is now the Farmoor reservoir.

Now hidden below the surface of the reservoir is Farmoor Common, a field name within the tything which gave a name to the reservoir. The present village was not here before the early years of the twentieth century, therefore the 'far moor' must have been some distance from the near common land which was presumably closer to Cumnor.

Fawler

The earliest record of this place is from 1205 as Fauflor, yet the name is the result of something at least twice that age. The name comes from the Old English fag + flor, spoken by the Saxons they reported what they found beneath their feet literally a 'variegated floor' and referring to a tessellated pavement. This is a direct reference to those who were here before the Saxons, the Romans, who produced large mosaic flooring for many of their buildings. It must have seemed very unusual for them to find such decorative flooring when they were still living in huts with little more than straw for a floor covering over the bare earth.

Within this parish is the name of Leerest Farm, which is recorded in 1603 as being the estate of Sir Henry Lee. The record states that in this year King Charles I and his consort Queen Henrietta Maria had spent the end of the summer at Woodstock and went from here to visit 'Lee's rest' three miles away.

Fencot

This name comes from cote-fen or 'the cottages of the marshy ground' and, with a variety of spellings, has remained unchanged since the twelfth century. Similarly the local name of Murcot here has changed little over the same period and, while it has historically been a quite separate settlement, has the identical meaning but based on mor - cot. We also find Marlake House, itself taken from the name of 'the boundary stream' and the ancient marker of where Oxfordshire ends and Berkshire begins. As seen under Charlton on Otmoor, the name of Otmoor comes from 'Otta's fen'; Hatch refers to 'a floodgate' and Hecate 'the road to the floodgate'; Winding Lands is that 'land alongside the meandering river'; and Struttle Mead takes its name from the dialect term for the stickleback or Gasterosteus trachurus.

However not all the names here are derived from the wetlands. Street Hill takes its name from the former Roman road which crosses the River Ray at this point. Culver Butts is 'the unploughed margins of the field where wood pigeons are seen'.

Fewcott

This name does originate from Old English feawe-cot, quite literally 'few cottages'. However this is likely to suggest 'humble cottages' rather than a small number of properties.

Fifield

A name recorded as Fifhide 1086, Fifide 1241, and Fifede 1346 which certainly comes from 'five hides'. Place names which are multiples of five are quite common. Here we also find Roughborough Copse from 'the rough hill', a reference to the terrain and the undergrowth.

Filkins

An unusual name recorded as Filching in 1173, Filkinges 1180, Fulking 1229, and Filechinge in 1269. These forms are a little late to be absolutely certain, yet this does appear to be '(place of) the people of Filicia'.

Locally we find The Pills, a name from Old English pyll and only used in place names to refer to 'a small stream'. However there is a reference to aewielm which is also the origin of the place name Ewelme, meaning 'the source of the river'. There is no other connection in these two names or places.

Finmere

Listings of Finemere 1086, Finmere 1251, Fymemere 1297, Fymmere 1331, Fynner 1428, Fynmour 1526, and Fenmore in 1675 leave the first element uncertain. There are two possible alternatives, equally plausible from the etymology, however that of fyne - mere or 'pool with mould' would neither be distinctive nor true for much of the year. Thus the more likely explanation is that seen in the following name and this is fina-mere, 'the pool frequented by woodpeckers'.

Finstock

This name comes from the Old English fina - stoc, being recorded as Finestochia in the 12th century but certainly was in existence many years prior to this. This name refers to 'the outlying farmstead frequented by woodpeckers'.

Locally we find the names of Illcott Copse from 'the cottages on a slope'; Patch Riding is a modern version of 'Paecca's ditch'; while Topples Lane and Topples Wood both take their name from 'Taeppa's spring'.

Forest Hill

While it may seem to be a completely natural name, it is the place which is referred to here. Of course many places simply refer to the region where they are situated, yet here the name is not as well hidden in Old or Middle English. However while this place is indeed from Old English hyll, the first element is not what it may seem. This is fyrst, related to Middle Dutch vorst meaning 'ridge of a roof', it again refers to the hill and specifically the ridge leading up to and on top of it. Interestingly the same combination is found in Dorset, where the name is given as Fossil Farm – quite applicable to the nearby Jurassic Coast perhaps, but just as wrong.

Shotover here comes from the Old English sceot-ofer, the first element of which can literally be defined as 'shoot' and understood as 'steep slope'. Riding Lane and Riding Way Gate both come from the Old English ryding meaning 'cleared land'; with the Dipping telling of the place where the sheep dip was located.

Foxcombe Hill

Listed in 985 as Foxhola cumbe, this name really does mean 'valley of the fox earths'. Although it may seem unusual to name an area after such a common sight, it should be realised that this highly successful animal occurs in greater numbers today than at any time in history. This has nothing to do with the banning of blood sports. It is simply that the fox is a generalist and can take opportunites which are not viable for a species with a particular prey. Human rubbish tips are ideal habitats and the fox thrives equally well in the country as in the town.

Frilford

A name found in the 1086 record of Domesday as Frieliford. Here is a Saxon place name which describes 'the ford of a man called Frithela'. It is likely that the ford was maintained by this man, or his family, and who charged a small toll to pass here in exchange for reducing the journey of travellers considerably.

Fringford

There are over twenty different forms of this name surviving since the earliest of Feringeford in Domesday of 1086, however none make the first element here certain. It is undoubtedly a personal name, it is the form which is the problem - akin to distinguishing between Mike, Mick, Mickey, Mitch, etc. This is therefore something not unlike 'the ford of the family or followers of Fera', the personal name being followed by inga-ford.

Waterloo Farm was land purchased by a Mr Harrison and, fully operational shortly after, was named in celebration of the famous victory which would have been the major topic of conversation at the time. There is no reason to suspect the man was present at the battle, although it is probable he knew someone who did fight for against the French.

Fritwell

Several springs here could have given rise to this name, listed many times over the centuries from Fertwelle in 1086 to Frightwell in 1580. This is probably derived from freht-wielle 'the wishing well', not as we would see it today but a shrine, maybe even a place of pagan worship, which would be visited in the hope of good fortune for the coming agricultural season.

Field names here include London Way, a remoteness name; Lank Furlong, the long piece of farmland; and Lunch Furlong, not a place for the midday break but 'a lump of land' which was a good description of its odd shape.

Fulbrook

A fairly common name which refers to 'the foul brook', a small stream which is particularly muddy and unsuitable as drinking water.

We also find Cobbler's Bottom a from 'Cobba's lower land' – a personal name never found other than in place names. Smalloaks Copse comes from Old English smael - ac or '(place at) the slender oak tree'. Westhall Hill takes its name from west - healh which tells of 'the western corner of land'.

Fyfield

There are four other places named such in the country, tellingly in the south of the country. This name refers to a measure of land, the 'hide', and could not readily appear in north of England for that was dominated by the Danes and the equivalent area of 'carucate'. The hide is a somewhat ambiguous measurement for in the early times (when this name would first have been heard) it referred to an area needed by a family to support them throughout the year. This is questionable, for it depended more upon the productivity of the land and the size of the family. In later years the area was said to be equal to four virgates, this being the area ploughed by a team of two oxen in a single season. Again this depended upon the quality of the soil and the terrain. However it did mean that the hide was more easily defined as roughly equivalent to 120 acres.

The name of Fyfield is recorded as Fif Hidum in 956 and Fivehide in 1086, the latter showing the name to be 'the estate of five hides of land' and coming from Old English fif-hid. Whilst this name may not tell us how many people the land supported, it does tell us the size of the estate remained consistent for a substantial period of time. From this we can deduce that the population would have remained fairly static for that same length of time.

The local pub is the White Hart, an heraldic image symbolic of the royal hunt.

Chapter Seven

G

Gallos Brook

A name which comes from the same source as that of Gallowsgreen. Here the name speaks of 'the brook by the gallows'.

Garford

A name recorded in 940 as Garanforda and the following century as simply Wareford in Domesday. We can disregard the latter record for Domesday is notoriously unreliable when it comes to proper names and furthermore there are no other similar records of this form. Turning our attention to the earlier form we find the origin to be Old English gara - ford. This may lead to one of two possible meanings – either this is 'the ford at the triangular piece of ground' or it is 'ford of a man called Gara'.

Garsington

A name recorded in Domesday as Gersedun which undoubtedly comes from the Old English gaersen-dun. It seems likely that this name was given to this feature in the landscape first of all, later being taken by a settlement which was found nearby.

Kiln Farm is a site of one of the many potteries along the Thames Valley which had existed since Roman times; Comberwell Field is name for the 'spring in the valley'; and March Crouche tells of 'the cross in the marshland', part of the shaft of the old marker cross still stands here.

Glyme (River)

A river name recorded as Glim in 958 but much older than that. It derived from a British or Celtic glimo meaning 'brightness' and a reference to a sparkling stream.

Glympton

A name recorded in 1050 as Glimtuna, in 1086 Glintone, 1199 Clinton, 1231 Clinctona, 1235 Clantona, 1252 Glimpton, 1268 Climpton, and in 1284 as Ghimpton which points to 'the tun or farmstead on the River Glyme (see above).

Locally we find Berrings Wood or 'the wood of the burials'; Hobbard's Hill began life as 'the hopyards hill', although this may have been transferred in the form of a personal name; and Slape Bridge was erected at 'the slippery place'.

Godington

This place name is found as Godentone 1086, Godinton 1200, Godingedon 1215, Gotenden 1241, Gadindon 1246, and Godigdon 1278, which shows there has always been some confusion as to whether this has the suffix dun or tun with a tendency to alternate between the two. Yet, even though the earliest forms show otherwise, the majority do show this as dun and therefore 'the hill of Goda's people'.

Gosford

There can be no doubt this is from Old English gos-ford or 'the ford frequented by geese'.

Cutslow is a local name telling of 'the burial mound of a man named Cuthen'. Frieze Farm originally referred to a wayside chapel in nearby Yarnton, later seen in Gosford as Adam Fres and Alice Fres, although whether the people gave their name to the place or took it from the chapel is unlikely to be known. Pixie Mead comes from 'Pica's meadow'; and Sparsey Bridge tells of 'the island of land frequented by sparrows'.

Goring

Effectively two places separated by under two miles. Goring Heath can be considered to be an outlying settlement founded by the main town. The basic name comes from the Old English describing '(the settlement) of the family or followers of a man called Gara'. The main town itself is also referred to as Goring-on-Thames, the river describing a loop around the place to the west.

Here is a region known as Cray's Pond which is derived from an error, as the name of the landholder here was Gray. Formerly known as Appulhangre 'the apple orchard on a slope', it became Beech Farm after the arrival of John Beche somewhere before 1359. Cleeve is always used to describe 'a cliff' but meaning a sharply defined riverbank.

Elvendon Farm is recorded as Elvedune in 1260, and showing this has long been associated with creatures of folklore for this means 'the farm at fairy hill'.

Gatehampton is named for 'the home farm where goats are reared'; Hartslock is from 'the stile by the lock in the land of the Hurt family', the lock would have been a locked gate for this was well over a century before the word for a river lock was recorded; Haw Farm takes its name from an earlier farm settlement or haga in 'enclosure'; Holme Copse is 'the small wood where holly grows'; Lycroft is from laege-leah 'the woodland clearing allowed to remain fallow'; Stapnall's Farm was sited on 'the steep hill'; and Wroxhills Wood tells of 'the corner of land where buzzards are seen'.

Battle House here was not named after any major conflict but former occupant William Bataill, similarly Hyde's Pond recalls Walter Hyde, Collinsend Common is connected with Robert Colyns who was here in 1337, and Grigg's Wood is after Adam Grigg recorded here in 1270.

Grafton

A place name found as Graptone in 1086 and Graftona in 1130, and which comes from Old English grafa - tun and telling of 'the farmstead by or in a grove'.

Here we also find Radcot which would normally be a personal name with the element cot – however here the origin is 'reed cottage', which refers to the reeds used to thatch the roof.

The White Swan, Radcot, near Grafton.

The Thames at Radcot.

Great Coxwell

This name was recorded as Cocheswelle in 1086 and Cokeswell in 1227, the name being a Saxon personal name followed by the Old English wella. This tells us this was '(the place at) the spring or stream of a man called Cocc'.

Great Haseley

A name recorded in 1002 as Haeseleia and in 1086 as Haselie. This comes from the Saxon haesel - leah, referring to '(the place at) the clearing among the hazel trees'.

Latchford is a name which comes from Middle English lache and Old English ford and telling us this was 'the ford across the stream flowing through boggy land'. A local dialect word of lob, used to describe 'a wide lump of ground', would seem to be the basis for the name of Lobb Farm - yet there is nothing resembling this around this region and therefore it can only have been brought here as a name of a tenant. Similarly Lobbersdown Hill will have the same etymology. North Weston was 'the eastern farmstead' and only received the addition to differentiate from South Weston. Rycote takes its name from ryge - cote or 'the cottage where rye is grown'. Band Furlong sees a common change in a name to 'band' from the original 'bean field'. Cobb Hall is 'the hall with the peaked roof' from the Middle English coppede.

The local inn here is the Plough, one of the most common agricultural names and one which, in the earliest times, would require only an old plough share nailed to the sign although today the idyllic rural scene is usually portrayed.

Great Milton

A common place name, Milton has the addition to distinguish from Little Milton nearby. The basic name has two origins, here the name comes from Old English middel - tun describing 'the middle farmstead' and is recorded as Midletone in 1086.

Chilworth Farm takes its name from an old minor place name. It is found as Celeorde 1086, Childeworth 1268, and Chelworth 1457, this comes from Old English and tells us of 'Ceola's worth' – a worth was a Saxon term for an enclosure, perhaps a pallisade and not a defensive feature for the people but to keep the livestock penned in close to home at night. Wheatley Bridge was constructed alongside the 'white woodland clearing'. However it was previously known as pons de Harpesford in 1228 and prior to that herpath ford in 956, which speaks of the 'ford of the army path' a name retained when the first bridge was constructed. Gore Common comes from gara 'the triangular piece of land'; The Breach means 'the newly cultivated land', although this was now centuries ago; The Lasher a field standing close to a pool created by the water splashing over the weir, while the name of the Old Mill Leat shows where the water was channelled from that weir to feed the mill.

Road sign at Rollright.

Great Rollright

Recorded as Rollandri in 1086 and as Rollendricht five years later, the name comes from a Saxon personal name followed by the Old English land-riht and tells us it was 'the property of a man called Hrolla'. The addition is to distinguish from Little Rollright.

Around here we also find Danes Bottom from 'the deep valley lowland', with the old forms showing a basis in Old English deop-denu with the first element now lost. Tyte End features tite, an obscure Cotswolds term describing 'a small rivulet dammed to provide water for domestic use', which may seem a long definition for a four letter word but this is certainly the concept.

Great Tew

A name found also in the county as Little Tew and Duns Tew. Here the name is derived from the Old English tiewe and refers to '(the place at) the row or ridge of land'.

Named for the successful campaign of 1982, the Falkland Arms was briefly the most popular new name for old pubs and new pubs alike.

The Whispering Knights at Great Rollright.

<p style="text-align:center">Chapter Eight</p>

Hailey

A name recorded as Haylegh in 1240, Hagele in 1246, and Halylegh in 1268, which comes from Old English heg-leah or 'the woodland clearing where hay is harvested'.

Within the parish is Delly Pool, a name which comes from 'the woodland clearing in the valley'; while Poffley End is taken from 'Pohha's stream'. The name of Shakenoak Farm is first found in the late thirteenth century as le Forsakenhoc literally 'the deserted oak' and describing the only tree in a clearing. Later records are different and suggest the area was now an extensive wood yet the original meaning of the deserted oak remains.

With a local named the Bird in Hand, it suggests a better establishment than the competition, for it takes advantage of the adage "A bird in the hand is worth two in the bush".

Hampton Gay

Early forms of this name include Hantone 1086, Hamtona Gaitorum 1130, Amtune 1173, Hemptone Gaytorum 1185, Hampton la Gai 1195, and Ampton Gaye in 1263. As with the following example this is the ham-tun 'the home farmstead', here the addition is from Reginald Gait, also referred to as le Gayt and de Gay, who was here by 1170.

Hampton Poyle

A common enough element in place names with three different origins all producing the modern Hampton. Here the Old English ham - tun tells us it was 'the home farmstead', and is recorded as Hantone in 1086. In 1428 we first find the addition as Hamton Poile, the manorial addition is a reference to the de la Puile family, although they had been here since the twelfth century and who married into the family who had held this manor since the eleventh century.

Road sign at Hailey.

Hanwell

A place name derived from the element weg and preceded by a Saxon personal name which tells us of 'Hana's roadway'. It is only since the fifteenth century that the suffix has been mistakenly recorded as coming from wielle.

Hardwick

This name is found as Hardewich in Domesday, Herdewic in 1123, Herdwic in 1205, Herthewyk in 1339, and Hardwick Audley in 1580, this last record showing the primary landholder of the time William de Audele. A common place name which always comes from heordewic 'the specialised farm of the flock'. While the more obvious origin is 'herd' this is never found in combination with wic to refer to a dairy farm.

Minor names here include Tusmore a name which has been the subject of much discussion and speculation. From thyrs-mere comes the possible 'pool of the giant', or perhaps a personal name in 'Thur's pool', or even a religious reference in 'Thunor's pool'. Of these the second is the most rational to explain, yet the superstitious origins are equally plausible and would be readily accepted if there were a surviving tale from folklore.

Yelford tells us this was 'Aegel's ford'; Cokethorpe Park is probably 'Cocca's outlying farmstead', although there is also a small chance that this refers to a farm bird; Boy's Wood reminds us that this region was held by John du Boys in 1278; while Berryham Plantation comes from the place name which speaks of 'the fortified place in the water meadow'.

Harpsden

Records of this name are found as Harpendene 1086, Arpnden 1246, Herpedene 1263, Harpesden 1275, Harpden 1441, and Harden 1761, with a number of similar

contemporary spellings have failed to produce a certain meaning. There is a record from 1176 describing a number of boundaries, including one which apparently ran andlang hearp dene - which literally seems to translate to 'along harp valley'. While this would fit well with the records of the place name, the modern place looks little in the way of being harp-shaped. This does not mean it should be discounted, it is quite likely the true origin, but simply that the reason for the name cannot be offered without further evidence.

Bolney Court and Lower Bolney Farm have a common origin in bulena-hyo, which translates to 'the landing place for bullocks'. Kentshill Wood and Kent's Hill are not named before the middle of the nineteenth century, while there are records of John and Robert de Kent many years before and their family would certainly have brought the name here. The Slipe is a field name referring to a narrow strip of land, while Great Rice Eyot which has nothing to do with the crop but is a corruption of 'the larger rising small island'.

Haseley Brook

Taken from the place names of Great and Little Haseley, it means 'woodland clearing where hazel grows'.

Headington

A name found in a document of 1004 as Hedenandun and as Hedintone in 1086. This is a Saxon name with the suffix dun and speaking of 'hill of a man called Hedena'. As if to emphasise the meaning there is also the more recent settlement less than a mile to the east of Headington Hill.

Street names around Headington commemorate landowners, dignitaries, businessmen and investors who have made a significant impression on the place over the years. Both local and national politicians are well represented; local MPs who gave their names to the streets here include Thomas Stonor's seen in Stonor Place, Edward Cardwell in Cardwell Crescent, Sir William Harcourt gave his name to Harcourt Terrace, Viscount Valentia is marked by Valentia Road, and Frank Gray is seen in Grays Road; former prime ministers William Gladstone, William Pitt the younger and the William Pitt the elder are seen in Gladstone Road and Pitts Road. The work of Oxford MP Sir Thomas Stapleton is marked by Stapleton Road, while Bickerton Road is named after former town clerk Joseph Jones Bickerton. Oxford's former mayors are well represented too – Alden Crescent, Atkinson Close, Burchester Avenue, Chillingworth Crescent, Dora Carr Close, Fettiplace Road, Flexney Place, Franklin Road, Ingle Close, Langley Close, Pauling Road, and Underhill Circus. To some degree Leiden Road is a political name, for this is the twin town in the Netherlands.

Local figures gave their name to Pether Road, after a nineteenth-century farmer whose grandson was William Morris, who became Lord Nuffield and was the basis to Nuffield Road. Lewis Close is a reminder that a home of author C. S. Lewis stands here; former Oxford photographer Henry Taunt is recalled by Henry Taunt Close; a former GP gave his name to Acland Close; Gathorne Road and Girdlestone Road are named after Gathorne Girdlestone, a once famous surgeon; while Sir William Osler, at the beginning of the twentieth century the biggest name in medicine, is rightly remembered by Osler Road.

The family who worked Southfield Farm gave their name to Burrows Close; Finch Close were landowners around the Rookery; both the Franklin family of Franklin Road and the Holley family of Holley Crescent were farmers; Latimer Road is named after the family who once lived at Headington House; the Mathers of Mather Road were farmers; Headington Hall was the home of the family who gave their name to Morrell Avenue; and Wharton Road remembers the Whartons of Headington Lodge. Manorial family names are also popular as street names – examples here include Bassett Road, Brome Place, Peppercorn Avenue, and Wilcote Road.

However these families could not and did not earn their place in history alone. A list of workers and servants are quite rightly remembered in names such as Bateman Street, Bushell Close, Cooper Place, Coppock Close, Gardiner Street, Gurden Place, Hedges Close, and Trafford Road.

There is some tenuous link between the names of Douglas Downes Close remembers a former economics tutor; the architect of Magdalen College's place of worship proved the inspiration for William Orchard Close; this in turn leads us to John Snow Place, a reminder of the nineteenth century stone mason; and from there back to the fifteenth century and the names of the quarrymen seen by Norton Close, Piper Street, and Kennett Road.

Local history is a favourite source for names required by new developments. Titup Hall stood on the site now occupied in part by Titup Hall Drive. Brookside reminds us Boundary Brook was covered over and now runs beneath the ground; Holyoake Road takes its name from the former dance hall; Mattock Close recalls Mattock Nursery, while Nursery Close is named after the old Ryman's Nursery; Stile Road runs through the site of a former stile. Old field names magically reappeared after the cutting of Bulan Road, Dene Road, Highfield Avenue, Sandfield Road and Southfield Road.

Ethelred Close is named after King Ethelred, the earliest known inhabitant of Headington to be named. Not far from here is Dunstan Road, named after the man who served as Archbishop of Canterbury and who was instrumental in bringing Ethelred to the throne. Shortly before Headington became an administrative part of Oxford it had its own rural council under the chairmanship of Captain Mark Ulick Weyland, his name is perpetuated by Mark Road and Weyland Road. Captain Weyland's heritage is an impressive one, particularly through his mother's line who was a descendant of poet and former prime minister George Canning.

As housing needs continue to grow developers are forced to build to accomodate the demand. As there is a finite number of individuals who could ever merit having a road named after them, many councils have resorted to using themes for a region. Tree names were used to produce Ash Grove, Beech Road, Blackthorn Close, Chestnut Avenue and Hawthorn Avenue, while the places around England's first national park, the Lake District, have been given to Ambleside Road, Bowness Avenue, Coniston Avenue, and Derwent Avenue.

However it is refreshing to find street names still being chosen to mark some of history's less well documented moments. Christmas 1899 and two gentlemen were brought together by pure chance. The Sharp family were spending the festive season with the in-laws, bad weather had slowed building work here and the foreman of the building firm was trying to earn a few pennies playing the concertina for the Headington Morris Dancers. Boxing Day 1899 was a momentous day for morris dancing in England, for afterwards the revival of the traditional art form can be traced to that moment. Today we find Cecil Sharp Place and William Kimber Crescent, names which few will know the significance of.

The pubs around here also reflect the history of the place and the nation as much as its streets. While the Royal Standard and Crown & Thistle are variations on a theme of showing support for the monarchy and a national pride, there are also local references such as the Quarry Gate. The Black Boy is invariably a reference to foundrymen, perhaps an earlier trade of the owner or innkeeper, the Fairview Inn a name typically used by those wishing to give a good first impression and popular with developers, while the Corner House tells potential customers where to look for the place.

Henley on Thames

The river name is discussed under its own heading, but is clearly the major water course near this town and added owing to the number of settlements named Henley in the land. This comes from the Old English heah - leah literally describing 'the high place of the woodland clearing'. This should be seen as high in the sense of importance rather than elevation.

The street names of Henley come from a variety of sources, some with a quite complicated history. For example Bell Street is named after the inn which stood here, later Bell Street Mews was named after the main road. However this was not the first name considered, for previously Robbins Place was suggested after the builder who plied his trade from this location, while the alternative Pither Place was to remember Raymond Pither, a former mayor who owned both a bakers and a butchers shop on this site. The names of four individuals who were created freemen of the town for their work were also taken for the names of Crisp Lane, Simmons Road, Clements Road, and Luker Avenue.

Chalcraft Close recalls the former president of the Brakspear Brewery, who died in 1985. Fortunately a sharp-eyed resident noticed the minutes had mistakenly said the name

The entry sign to Henley on Thames.

was to be Chalcroft Close, giving time for the order to be changed before the street signs were produced. Leaver Road was named for Ernie Leaver, a former town clerk. While Gainsborough Hill, Gainsborough Road, and Gainsborough Crescent are often wrongly thought to remember the famous painter. In truth they were named after his brother Humphrey Gainsborough, an engineer of some standing who came to Henley in 1748 and served as minister of the Congregational Church. Hart Street is, like Bell Street, named after a former inn which stood in this street. Rupert's Place is a memory of the English Civil War, when Prince Rupert of the Rhine was the righthand man of his uncle, King Charles I.

Wharf Lane stands near the wharves employed when Henley was an important port. From the same era, and for the same reasons, is the name of Pack and Prime Lane. After the boats were unloaded the only method of transport was by pack horse. The route taken through the woodland was a dangerous one and, as they were called together to start on their way, their leader would give the order to move out by calling out "Pack your packs and prime your pistols".

A tributary of the Thames gave its name to Brook Street which, through the development of the town, eventually became little more than a muddy track. To make it somewhere near usable wooden planks called duckboards were used to cover the muddy surface, which gave it the local name of Duck Street which eventually was changed to Duke Street to fit in with nearby Earl Street.

Yet surely the most interesting etymology for a street name in the town is that of Friday Street. This route would have been in use for many years before it was first officially recorded as such in 1305, they were heading for the fishponds which had been separated from the river to provide fish for the church. Fish were required for meat was not allowed on a Friday by the Catholic Church.

The field names of Henley reveal their own story. Hither Ascension, Further Ascension, and Middle Ascension are three fields on slopes at varying distances from the main body of the farm buildings. Clapper Wood Hill is a name recorded as simply the Clapurs in 1479 and le Clapers in 1483, a clapper is a term for a rabbit burrow. While The Half Moon may seem a decent name for a pub as it was simple imagery, for the same reason it described the shape of a field perfectly, for the same reason as the naming of the field known as The Spectacles. Further Neaplands features the dialect word neep, today associated with Scotland it was once used here for 'the turnip field'.

Local inns include names which further tell of the close association with the river. Among them are the Anchor, an excellent visual symbol found in many places to show a connection between the sea and the owner or landlord. A vessel often used to convey royalty along the river is recalled by the Row Barge Inn, while the Angel on the Bridge has a cellar built around a complete arch of an early bridge at Henley. The original building here was a hospice called the Hermitage, almost certainly the reason for the addition of 'angel'.

A brewing theme is marked by the Maltsters Arms, while an invitation to a warm welcome is promised by the name of the Rising Sun and the Idle Hour when there is nothing else to do. Found in various forms as a pub name, the horseshoe is a simple image, suggests good luck, and in the earliest times points to the blacksmith service often found next door. Here the name has a fairly unusual number as the Five Horseshoes.

Famous people are often commemorated in pub names, although not always obviously. It is no surprise to find the Prince Albert recalls the consort of Queen Victoria, however few would realise their fourth daughter Princes Louise married John George Edward Henry Douglas Sutherland Campbell, Marquess of Lorne, who is remembered

by the Argyll as he became Duke of Argyll. Other familes are represented heraldically in the Old White Horse and Saracens Head.

The Golden Ball appears an obvious pub name and, in the true tradition of 'coloured' things being of heraldic origin, seems another example. However this may be exactly what was intended for none of the pubs in the country with this name can be linked to a heraldic image. We must assume it was intended as a typical pub name, while providing a truly simple design.

Hensington

The basic name here is thought to be from the Old English telling us of 'the farmstead of the stream known as Hensing'. Which of course leads to the question of the meaning of the stream name, and is probably from hens which refers generally to 'wild birds'. It is unheard of for British river names to have such a theme and therefore this is almost certainly a Saxon name, albeit an unusual one.

Hensington has given its name to two adjoining places with the highly unusual additions giving Hensington Within and Hensington Without, which have no true etymological value but were simply created to be different.

Henwood

A name recorded in the twelfth century as Hynewode. A name which comes from the Old English hiwan-wudu, telling of 'the wood of the monastery'.

Hethe

Despite this name being recorded as diversely as Hedham, Hetha, Hehe, Etha, Hethre, Haze, Eche, Heche and Thad between 1086 and 1295, this can only have come from Old English haeth meaning 'uncultivated land' but effectively describing exactly what it would mean today 'heathland'.

Willaston Farm takes its name from the small settlement there which, in turn, began life as 'Wiglaf's farmstead'.

Heythrop

Domesday lists this place name as Edrope which, as discussed in the introduction, is an error by the Norman surveyors and can be discounted. Later listings tell us of Hethrop 1223, Hatorp 1230, Hestrop 1270, and Hegtrop in 1285, which are undoubtedly from heah - throp or 'the high village'.

One local name of similar origins is Dunthorp which has probably been influenced by the main name and comes from 'the village on the hill', although there is something to be said for the alternative of 'Dunna's village'.

Highfurlong Brook

It was formerly known as Cranemeare in the middle of the sixteenth century, a true river name from Old English cran-mere 'the pool where crane or heron are seen'. The modern name is taken from a field and refers to the important 220 yards, rather than its elevation above sea level.

Holton

Listed as Healhtunes 956, Eltone 1086, Haltona 1167, and Haleton 1205, this comes from the Old English healh-tun or 'the famstead in the sheltered valley'. Vent Field probably refers to a public drain which crossed this place; Knee Ley Meadow tells us this was 'the woodland clearing shaped like the bend of the knee'; The Racks is a regional Middle English term for a 'narrow track or path'; Parsonage Meadow was land associated with a church, as was Spittal Meadow a wing dedicated to the sick and an early 'hospital'.

Holwell

A name found as Holewella in 1189, Haliwell in 1222, and Halewille in 1285. Here the Old English halig-wielle speaks of 'the holy spring or stream', it is unknown as to why it was considered holy but is thought to be a pagan deity.

Hook Norton

There are several places named Hook in England, although there different origins. This place is listed as Hocneratune in the early 10th century, showing this is not a normal 'northern tun' as we would expect. Here the name refers to 'the farmstead of a tribe called Hoccanere'. This is an Old English tribal name referring to 'the people of Hocca's hill-slope' – derived from a Saxon personal name with ora and tun.

Minor place names of this parish include Upper Berryfields Farm and Lower Berryfields Farm, which refer to 'the fortification or earthwork of the open land'. From butere-hyll comes a reference to the excellent pasture for the dairy herds which grazed on Butter Hill. Hayway Lane was used to transport the harvest of winter fodder. Southrop began life as 'the southern outlying farm'. However the name of Sugarswell Farm is not as sweet as it sounds, for the origin tells us this was where the 'robbers spring' was, a region where criminals and thieves were thought to hide out.

Pubs found in Hook Norton include the welcoming sign of the Sun Inn, a pub which had a fruit tree nearby is the Pear Tree Inn, and where the earliest sign was simply a gate hung outside the Gate Hangs Well Inn.

Horley

Derived from the Old English horna-leah this place name is listed in Domesday as Hornelie. The name describes '(the place at) the woodland clearing in a horn-shaped piece of land'.

On 21 November 1783 Francois Rozier and the Marquess d'Arlandes took the first ever balloon flight, two years later Blanchard and Jeffries achieved the first crossing of the English Channel. Both balloons were the creation of the Montgolfier brothers and the sensation of the age. The Air Balloon pub was one those named to commemorate this landmark. To show a meeting place of the Ancient Order of Foresters, a friendly society known as a lodge or court, pubs hung a sign bearing the name of the Foresters Arms. The Bell is a common name, owing to the long association between the local tavern and the church. Because of the number of places there is often an addition. Sometimes, as with Ye Olde Six Bells, the number informs us of the peal.

Hornton

This place is seen as Hornigeton 1194, Horningtun 1195, Hormintun 1213, Horniton 1236, and Horingtone 1285. Here the name comes from 'the farmstead of the Horningas', a name given to the people who lived in the horna or land between the streams. That the people took the name of the place where they lived is revealing, although what it is telling us is uncertain. In order to earn the name they must have been said to have been different by their neighbours, and for an appreciable length of time. We can possibly speculate further and suggest they were solitary, unlikely to mix, possibly aloof or even unfriendly, however we shall never know the real reason why.

As it produced an easily recognisable symbol, the Dun Cow was a popular pub name.

Horspath

Recorded in 1086 as Horspadan, in 1225 as Horspade, in 1242 as Horsepathe maior, in 1285 as Horsepasche Templariorum, and in 1325 as Netherhorspath. This comes from the Old English hors - paeth, 'the path used by horses'. The late thirteenth-century record tells of ownership of these lands by the Knights Templar.

Bullingdon Green comes from 'the valley where bulls are reared'; Costard Furlong is a field name referring to 'the place of the cottages'; and Swillow Furlong was where swallows (possibly swifts) were seen.

Horton

Listed as Hortun in 1005 and as Hortone in 1086, this name comes from the Saxon or Old English horu-tun meaning 'dirty or muddy farmstead'. The place is also given as Horton-cum-Studley, the other is a minor place name which comes from stod - leah 'the woodland clearing for horses' – literally a stud.

Claret Well Hill is near the spring trickling across red clay.

Chapter Nine

I

Icknield Way

A Roman road and one of the nations longest and best known roads. This is no Old English name, the road was here and probably in need of repair in places by the time the Saxons arrived. For some of the time this road, where it crossed Oxford, seems to have been known as Akeman Street. This ancient road ran from Dorset to Norfolk and had probably done so prior to the arrival of the Romans. Indeed the etymology of the name is so old it has never been discovered, not so much as an idea of where this name came from which, in itself, is indicative of just how old this name is.

Idbury

With records of Ideberie in 1086, Edebur in 1268, and Edbury in 1675, there can be no doubt this is from 'Ida's burh or fortified place'.

Local names include Bould or 'building', which must have been a particularly impressive construction; Foscot is named after 'the place of the foxes earth'; and also field names Large Pan and Little Pan describing 'the field in the hollow'.

Iffley

This name was recorded in 1004 as Gefetelea and in 1086 as Givetelei. It seems likely this derives from the Old English gifete - leah, describing 'the place at the woodland clearing frequented by the plover'. It may be that the bird in question was not an actual plover but a bird closely related to that in appearance.

Here is Hawkwell, a name which dates from at least the thirteenth century and telling us of 'Horca's spring or stream'. Field names around here include The Grates, from Old English greot which although literally means 'grit' it is here used to refer to

'finely grained soil'; while Worgs path comes from the dialect term wergs referring to the willow trees which grew here.

Pub names often commemorate royalty, as does the Prince of Wales at Iffley.

Ipsden

A name recorded as Yppesdene in 1086, Ypeden in 1204, Hippesdene in 1212, Ybestane in 1219, Ybbestan in 1219, Hispedena in 1225, Irpeden in 1233, Ipelesden in 1248, and Ipseden in 1469. The suffix here is Saxon denu and gives 'Ippe's valley'.

Basset Wood is named after the place at nearby North Stoke, itself named after Thomas Basset. Berins Hill is probably from byrgen, here used in the plural to describe 'the burial mounds'. From byxen - ora comes 'the slope where box trees grow' and seen today as Bixmoor Wood. While Breach Wood comes from Middle English breche 'newly cultivated land', it also tells us the original woodland was cleared for the farmland and later abandoned to allow the wood to recolonise the land once more. Garsons Hill is 'the grassy enclosure' from gaers-tun, and holh-mere the 'pool in the hollow' which has evolved into Homer Farm.

Hailey is a name telling it was 'the hay wood', similar in sound and meaning to Heycroft Wood or 'the hay croft'. Uxmore Farm is uncertain but may be from yxen - mere 'the pool where oxen are seen'. Great Wichelo Shaw is a somewhat unusual evolution for a name, however it is undoubtedly from 'the woodland where wych elm grows'. Leyend Pond is a corruption of 'lane end pond'; Button Close is a field name using a local term for 'small mushroom field'; Charity Pightle was donated for the use of the poor; The Grubbing has been cleared of trees and scrub; Lot Meadow was a region of common land which was later allocated by drawing of lots; Great Lousy Bush describes a region which should be avoided for cultivation as it was prone to infestation by plant lice; and Netley eyot is the 'island where nettles abound'.

Isis, River

This river name is recorded as Isa in 1350 and Isis in 1577. This stretch of the river Thames around Oxford has a name derived from an early record of England's major river. The Thames was recorded in 51 BC as Tamesis, here this was interpreted incorrectly as Thame + Isis, and the name somehow stuck. There was undoubtedly some association with the goddess Isis, although this is not the reason for its name as is often suggested.

Islip

Records of this name are numerous, from Githslepe 1050, Gihtslepe 1057, Letelape 1086, Istelape 1165, Histesleapa 1167, Hichteslapa 1169, Hiteslape 1173, Ystlapa 1186, Ystelapa 1188, Ictlap 1190, Yslape 1192, Ycteslepe 1203, Istlesap 1205, Itteslap 1212, Hislepe 1246, Thiccheslepp 1250 and Ythslep 1278 – these represent a small sample of the huge variety of spellings. This tells us it was 'the slaep on the River Giht', an old river name for the Ray. A slaep is related to slapor meaning 'slippery' and related

to Old High German sleifen 'to drag'. Together this suggests a landing place, somewhere goods were transported by sled, perhaps even a very wet and muddy place where there was insufficient draught for a ferry and a sled-like contraption was employed.

The local name of Chipping Farm comes from cippa-fenn or 'the fenland where logs were obtained', and which may have been already cut.

The ways out of Islip.

Chapter Ten

K

Kelmscot

The first record we have of this place dates from 1234 as Kelmescote, although the settlement is certainly much older. Here the Saxon personal name is followed by cot to tell us of 'the cottages of Cenhelm'.

Kidlington's village sign.

Kencott

Listings of Chenetone in 1086, Kenicot in 1150, Kencot in 1190, and Canicot in 1220, point to this name coming from Old English and speaks of 'Coena's cottages'.

Kennington

There are three places of this name in England, all three having somewhat different origins and meaning. Here the name derives from a personal name followed by the Old English ing-tun, as seen from the listing of Chenitun as early as 821 and again in Domesday over 250 years later. This describes 'the farmstead of the people of Cena'.

The local here is the Tandem, nothing to do with the bicycle for two as this pre-dates the man-powered mode of transport but is a reference to a horse-drawn vehicle. It has a sign depicting a two-horse gig and telling of how students would take a one-horse gig as far as the Tandem where a second horse was added to carry them to Steventon and its railway station. This was before Oxford had a railway link of its own, and when by-laws prohibited any gig to be drawn by more than a single horse.

Kiddington

With records of Chidintone 1086, Cudintone 1148, Cudigton 1230, Crudynton 1287, and Kedyngton in 1517, there is no doubt this place name tells us it began life as 'the farmstead of Cydda's people'.

Minor names here include Asterleigh or 'the woodland clearing to the east'; Wood Farm, which was lost an element as it was originally 'the spring in the wood'; and Maisey Copse is named after the Mazey family who are named here in 1822.

Kidlington

In 1086 Domesday listed this place as Chidintone, 'the farmstead associated with the people of Cydda' and derived from the Saxon personal name followed by ing-tun.

Within the parish we find Campsfield, which is derived from 'the farmstead of the family or followers of Cydela'. It is tempting to give the name of Stratfield Farm as 'the open land by the Roman road', however there is no evidence to support this. There is a number of seventeenth and eighteenth-century names referring to a stodfald or 'horse paddock' and the basis for the term 'stud' as a breeding ground for horses.

The local inns here are known as the Dogwood and the Nut Tree, quite unusual names and both from plants. The first refers to the shrub which has species all in most temperate climates, and likely a specimen was brought here at some point; the latter reminds us of a hazelnut tree which once grew in front of the pub, it is said to have been particularly prolific producing a heavy crop every year. The Rock of Gibraltar takes its name from an old 'remoteness name', a distant name given to the extreme corner of the parish, of Gibraltar and adapted for the pub name and its sign.

Kidmore End

First listed in the sixteenth century as Kydmore end, this name seems to have no origins in either Old English or Middle English. It must be a personal name, but records showing any likely basis for the name have never been traced. Until further information is available the name must remain uncertain.

Tanner's Farm was so named in 1822, taken from the name of a local family and not directly from the trade. Cucumber Hill is first found in 1840, in turn taking its name from Cucumber Plantation which has been grown in England since the thirteenth century. Tokers Green is named Talkers Green in 1797 and was likely a local meeting place around this time.

Kingham

During the eleventh century this name is found as both Caningeham and Keingaham. Both show this to be a Saxon personal name followed by the Old English elements inga-ham, telling us of 'the homestead of the family or followers of a man called Caega'.

Reflecting its rural heritage the local here is known as the Kingham Plough.

Kingston Bagpuize

Records of this name are found as Cyngestun in 976, Chingestune in 1086, and Kingeston Bagepuz in 1284. The basic name is found throughout England and is derived from the Old English cyning-tun or 'the king's manor or estate'. Here the addition is manorial, referring to the de Bagpuize family who held this place at the time of the Domesday survey in 1086.

Locals enjoying a glass in the Hinds Head are probably unaware this place is one of only two named such in the country. The male red deer, the stag or hart, has a number of pubs named after it but the hind, without the crown of antlers, is nevertheless a superb specimen and a fine choice for a name.

Kingston Lisle

As with the previous name this is 'the king's manor or estate'. Here recorded as Kingeston in 1220 and Kyngeston Lisle in 1322, the addition is again manorial, this time from the del Isle family.

While this is a delightful place name the local inn here has an even more wondrous name and even a story to tell of The Blowing Stone. Correctly referred to as the Sarsen Stone, it is studded with holes which when blown in precisely the right manner produces a sound which can be heard for miles across the downs. It is said that the stone was used by King Alfred when he rallied his troops in a great battle against the Danes in 871.

Kirtlington

A place name listed in 1000 as Kyrtlingtune and in 1086 as Certelintone. Here the Saxon personal name is suffixed by the Old English elements ing and tun, giving a meaning of 'the farmstead of the family or followers of Cyrtla'.

Mazes were often attached to important medieval houses. Only the most affluent families may have been able to afford to hedge them, most were not large enough to contain such extravagances and indeed were not necessary. These mazes have a religious significance, used to walk by the pious while they prayed. These places were known as Troy Towns, hence the name of Troy Lane. For reasons unknown the name was changed to Ivy Lane around 1920, yet thankfully had reverted to its original name by 1950.

Other minor names here include Cockshot Copse, 'woodland glade where woodcock could be trapped', nets were strung across the clearing and the fleeing birds would be caught; Cordle Bushes and Cordle Door 'the cold spring of the moor and meadow' respectively; Cranmoor Plantation is named from 'the strip of land frequented by cranes or herons'; Crutchmore Plantation tells us of 'the cross on the moor'; Foxtowns End Farm is 'the hill by the farm frequented by foxes'; Goldwell Spinney is named from 'the spring of the marigolds in the spinney'; the corrupted name of Gossway Copse was originally 'the enclosure of the goose'; Hoarstone Spinney tells of 'the spinney with the grey stone' and a likely marker stone; Northbrook takes its name from the small bridge which crossed the brook to the north; Roomer's Spinney tells us this was 'the rough pool by the spinney'; Washford Pits reminds us of the 'overflow of water at the ford' and where the river was liable to flood seasonally.

Chapter Eleven

L

Langford

Listed as Langefort 1086, Lanfordia 1233, and in the present form as early as 1316, this name is a common one describing 'the long ford'. The modern topography hides the actual meaning, for there are two ways this could be described as 'long'. Either this was the more commonly found description of where the watercourse spreads out, thus making it wider but shallower or it was where the stream was fordable for a good continuous length of its bed.

Langley

A common place name found throughout England, normally with an addition to differentiate from others. All have the same origin in Old English lang-leah giving 'the long farmstead'. It is recorded as Langeleya in 1230.

Launton

Recorded as Langtune in 1050, Lantone 1086, Langeton 1206, Laggeton 1278, and Langton 1428, this place name is derived from the Old English or Saxon lang-tun or 'the long farmstead'. This is a common place name origin, the only surprise being it has evolved to Launton and not the normal Longton or Langton.

Another name which may be misunderstood is that of Hareleys Farm which in 1797 was listed as Whore Leys, the true origin is nothing quite so scandalous. This is from the same origin as the place name of Horley, from horna-leah 'the woodland clearing in a tongue of land'.

Leafield

Listed in 1213 as La Felde it is derived from the Old English feld with an Old French definite article indicating it was written by a speaker of that language. The word describes 'the open land' and, while it is the forerunner of the modern field, it differs in that it has no true boundary hedge or fence or anything like a gate. The land was cleared, the boundaries simply formed by the vegetation which was left.

A look at the map will reveal local names such as Loughborough or 'Lufa's fortification'; while the names Studley Allotments and Studley Copse both speak of being near to 'the pasture for horses'.

When the Royal Navy ruled the waves, its ships were of oak. The great timbers of which the impressive fleet were constructed were of the heartwood and did not require seasoning. It is surprising how many timbers from these wooden ships were re-used in constructing houses, a number many miles from the sea. However many more claim to have recycled timbers from some of the nation's most famous vessels, without any evidence to support this. Whether the Navy Oak here was named because of an old timber or because of an old sailor is uncertain.

Lew

Here is a name recorded as Hlaewe 984, Lewa 1086, Lewes 1195, Leawe 1331, Leuwe 1341, and Lawe in 1384. It is a name which comes from Old English hlaew and speaking of '(the place at) the tumulus'.

Lew Church and the Pillar Box Cottage at Lew.

Lewknor

Listed in 990 as Leofecanoran, in 1112 as Leuecanora, in 1185 as Leouetanore, in 1227 as Lokenoure, and in 1254 as Leweknore, this name comes from Old English and is 'Leofeca's slope'. Nearby is 'the high wood' today marked on maps as Hailey Wood; 'the manor house in the fen' has become Moor Court; while the name of Home Pleck refers to 'the small piece of land adjoining the farm buildings'. Postcombe is 'swampy ground in the valley'; or 'gate post in the valley' depending upon if the origin is possel or postel repectively. Although it may seem so, the name of Nethercote is not 'the lower cottages' but from Middle English atten other cote for 'at the other cottages'.

Limb Brook

A small water course which rises in South Leigh. It is a corruption of Leigh ham 'the homestead of the woodland clearing'.

Little Coxwell

As given under Great Coxwell, this name refers to 'the spring or stream of a man named Cocc'. Historically there seems to be only mention of one Coxwell, which would seem to suggest the smaller place is simply an overspill from the original Coxwell. Today the two are little more than half a mile apart and separated by the A420 Oxford to Swindon road.

Little Faringdon

A name recorded as Ferendone in 1086, Parva Farendon in 1220, Farndon in 1278, and Faryngtone in 1526 which comes from the Old English fearn-dun and speaking of the '(place at) fern hill'. The addition of 'Little' was to distinguish it from Faringdon in neighbouring Berkshire.

Little Haseley

As with the previous name this is an overspill settlement from the original place, again just half a mile separating the two. As discussed under Great Haseley, the name refers to its location 'close to the clearing of the hazel trees'.

Little Milton

'Little' to distinguish it from nearby Great Milton. Normally this common place name tells of 'the farmstead with a mill', however here the name comes from Old English middel-tun 'the middle farmstead'.

Although names such as Hangman's Bridge are often nothing to do with the gallows, it seems here there may be a link. Yet it should not be thought of as a site for a hanging, but there is some evidence suggesting a former executioner once resided here or thought to be here. The latter is the more likely for executioners were afforded anonimity, for fear of misdirected retribution, and were even less likely to have revealed their identity after they had retired. The Farthing Bank is an even greater misnomer, although there is little difference with 'the bank for fording (the stream)' the meaning is quite different. The Fiddle is a field name from a dialect term for several plants, any of which could have been found here.

Little Rollright

Yet another minor settlement, likely to have been created as an overspill from the original larger place. Here 'the property of a man named Hrolla' is separated by almost a mile from its larger namesake.

Little Tew

Along with Great Tew and Duns Tew, here is 'the place at the ridge of land'. This place is only half a mile from its larger namesake.

Littlemore

The record of 1130 as Luthlemoria shows the origins to be Old English lytel-mor, not moorland but 'the little marsh'.

Lag Mead is a field name describing 'the long narrow marshy meadow'; Broken Furlongs is a highly irregularly shaped field; Graft Furlong is 'the grove field'; and Paddocks End the region marking the boundary of the farm or parish.

Long Hanborough

Recorded as Haneberge in 1086, this place has the Old English suffix beorge and describes 'the hill of a man called Hagena or Hana'. The addition is to differentiate from Church Hanborough which is a mile south of here.

Lower Heyford

Listed as Hegford in Domesday, this name comes from Old English heg-ford and tells of 'the ford used principally during hay making' is derived from the Old English heg-ford. The addition is distinguish from Upper Heyford less than a mile away.

Minor names here include Caulcott, which comes from ceald-cote or 'the cold cottages', this saying they were in an exposed position. The Cleeves here is used in a

plural and speaking of 'land on a river bank', although at the beginning of the nineteenth century the name appeared briefly as Clive Hook with the addition speaking of a 'spur of land'. Cold Harbour is a corruption of Caldhememere referring to 'the boundary of the people of Caulcott', as mentioned in the thirteenth century and referring to the boundary with Kirtlington.

The name of the Horse & Groom public house would have originally suggested quality stabling, or a man previously employed as a groom. Today it is a typical pub name and makes for an attractive sign.

Lyneham

This place name has few early forms, however we can still see Lineham and Linham, from 1086 and 1137 respectively, coming from 'the homestead where flax is grown'.

Merriscourt Farm seems to be named from the le Mire family who were here by 1244.

Chapter Twelve

Madley Brook

This is a not a true river name but a place name. There is no such place near here today and therefore it has either been transferred, which is highly unlikely, or this is a clue to a lost settlement. There are places called Madeley in Staffordshire and Shropshire, both from 'Mada's woodland clearing' and there is no reason to suppose this place is any different.

Mallewell (River)

Listed as Marwelle in 1422, there can be no doubt this name means 'boundary stream'. The boundary in question is between Roulsham and Tackley.

Manual Spring

A natural feature with a name which would suggest otherwise. However the etymology is identical with the previous name and this is again 'the boundary stream'. This stream separates Denton and Garsington.

Marlakes Ditch

As with the water courses called Mallewell and Manual, this is yet another corruption of a term telling of 'the boundary stream', here between Kelmscott and Lechlade in Gloucestershire. The origin of all three is Old English maere-lacu, which can be seen as the origin even though at first glance there is little to connect these names.

Mapledurham

We only find the listing in Domesday as Mapeldreham to be early enough to provide any information. However even the modern form leaves no doubt this comes from Old English mapuldor-ham and telling us this was 'the homestead where maple trees grow'.

Regulars of the Pack Saddle Inn are doubtless aware the name dates from a time before the railways and before the canals, when the sole method of transporting goods of any bulk was by pack horse. This would have been one of a number of stopping places, where fresh horses could be obtained, goods could be sold or traded, or simply a meal and a bed for the night.

Local names here include Trench Green, a name first recorded in 1375 which is used in the sense 'hollow path through a wood'. The path would have been used for centuries, as evidenced by the description of it being a trench or hollow, literally worn away between the trees. Huntley Wood is from a Saxon place name of 'Hunta's woodland clearing', Whittles Farm remembers 'the white hill' of the Middle Ages, Parkstrings Wood is a narrow strip of woodland usually found by a stream.

Families who have served as lords of this manor, either by purchase, inheritance, or marriage, have given names to a number of local features. Bardolph's Wood is after William de Bardolf, who was here in 1284; and Chazey Farm is after Walter de Chauseia, lord of the manor around 1180. Blagraves Farm is named after the family of John Blagrave, who is also mentioned in a memorial in the parish church. Hodmoor Farm is named after the Hodmore family who were tenants here by 1343. Stirrups recalls the farmer John Stirrup, here in 1758, while Edmund Toby was around Tobyshill Row in the late fifteenth century.

Applepie Pightle is a field name, describing the 'piece of land where the usable plants grow'. It is impossible to say what plants for this dialect word has been used to describe a number of different plants with a range of uses. Hopping Close is a field where the hop plant grew, while the angular or oddly shaped piece of land where heron or cranes were often seen appears as Pinx Heron on modern maps.

Marcham

Listed as early as 900 as Merchamme and in 1086 as Merceham, this is an Old English name from merece-hamm. This tells us it was 'the river meadow where smallage grows'. Smallage is wild celery, inedible until deprived of acrid and even potentially poisonous elements by cultivation.

The Crown has long been a popular image for a pub, simple and clear it shows allegiance to the monarchy and the country.

Marsh Baldon

Recorded in 1086 as Baldendone it is seen with the addition in 1241 as Mersse Baldinion. This Saxon place name is 'the hill of a man called Bealda', later with the addition of the Old English mersc meaning 'marsh'. There is also a Little Baldon, a

settlement which would have grown from the original Baldon and today the name is applied only to Little Baldon Farm. These additions were to distinguish from Toot Baldon, less than a mile away and discussed under its own heading.

The Seven Stars features the common star image. Initially used to symbolise the Star of Bethlehem or the Virgin Mary, its popularity increased as it was a simple image to reproduce. A greater number of stars gives signwriters more scope, and here aliteration is an added bonus.

Marston

A name found throughout the country, and always from the same Old English mersc - tun. This name is recorded as Mersttune in 1069 and tells us this was 'the farmstead in or by the marsh'.

There was once a mill here, apparently worked by a miller who was none too popular in the neighbourhood. Although the mill no longer exists, and its name no longer appears on maps, it was here and working at the end of the thirteenth century. Three elements have combined to produce a term of abuse which must have been long-standing for it to have become the name of Shitpilchmill – the first element requires no explanation, the second means 'garment' (referring to britches or trousers), and the third to the mill, or miller. Sadly this is the only record of the miller and we will never known why he was so despised.

The name of the Somerset House is taken from the building this public house occupies, while there must be more pubs named after Queen Victoria than any other monarch, and quite fittingly so, the Victoria Arms is somewhat different from the normal basic name. The Jack Russell is named after the vicar of Swimbridge, the man who gave his name to the breed of dog he helped to produce in the nineteenth century.

Here we also find the Friar, a reference to Friar Bacon. Roger Bacon was born in Somerset in 1214; a Franciscan monk who had an interest in natural science and experimented widely. Those resulted in the publication of Opus Majus, among other things, which were declared works of heresy in 1278. His work was destroyed and he lived his remaining years in the monastery, dying there in 1294.

Merton

A name recorded as Meretone in 1086, Meritona in 1123, with Mertone Temple and Merytone Bokkele in 1285. The basic name comes from mere - tun or 'the farmstead by a pool'. Even today Manor Farm, the name telling us it has held its position of importance for many centuries, has a small pool alongside the main hub of the buildings. Two records from the late thirteenth century show there were seven hides of land given over to the Knights Templar by the Earl of Northampton.

Field names here include Bean Furlong where beans were long the favoured crop; Gogmoor Leys where the 'boggy land in the marsh' could be found; and Long Stone Furlong where the soil was very stony and difficult to work.

Middle Aston

A common place name with an even more common addition for distinction would hardly seem a sensible combination, and yet this is the only one of any significant size anywhere. The addition, first seen in 1220, is to differentiate from North Aston and Steeple Aston, which also refer to 'the east farmstead' or 'tun'.

Middleton Stoney

Middleton is a simple place name and a common one, hence the addition. This place is listed as Middeltone in 1086, Mudelingtona in 1209, Mudelinton in 1242, and Middelington in 1251, it is derived from Saxon middel-tun 'the middle farmstead', here with the addition of 'on stony ground'.

There can be no doubt as to the origins of Beechen Clump, Birch Spinney and Nut Tree Spinney, the beech, birch and hazel are still known as such today. Yet the name of Mangthorn Wood, even though it is often used in place names and clearly refers to a plant, there is no clue as to what plant it refers.

Milcombe

A name which is found as Midelcumbe 1086, Mildecumba 1109, Melecumbe 1206, Midecumbe 1206, and Meldecombe 1379. This comes from the Old English middel-cumb meaning 'the middle valley'.

Milton (near Adderbury)

A name found as Middeltun in 1199, as Middelton in 1284, Middilton in 1285, Middelton in 1316, and Medilton in 1379. This last example gives some indictaion of how a place name, which clearly began life as 'the middle tun or farmstead', has evolved into something which would be expected to have identical origins to the following name. This is an excellent example of why it is vital that we have as many and as early records of a name as possible. Early forms are closer to the original language and assist in defining the name, later examples help to show the evolution and can give an indication of the use of the terminology or of personal names.

Milton (near Didcot)

A common place name, normally found with an addition to make it unique. The name is derived from the Old English describing 'the farmstead of or by the mill'. The mill was powered by water, for windmills were unknown in Saxon times.

At Milton we find the Admiral Benbow. John Benbow (1653-1702) is a man remembered for his heroic deeds against the French during the War of Spanish Succession. He died after being wounded during a five-day running battle and is buried

in Jamaica. He is the subject of a ballad and likely the basis for the Admiral Benbow Inn, the scene of the start of Treasure Island published in 1883.

Milton under Wychwood

This name is derived from the Old English middel-tun, or 'the middle farmstead'. Listed as Mideltone in 1086, the addition refers to the forest, itself a name meaning 'the wood of a tribe called the Hwicce'.

The Quart Pot is a simple advertising sign, but an effective one as it is different from the normal pint, glass or bottle.

Minster Lovell

A name recorded in Domesday as simply Minstre appears as Ministre Lovel in 1279. The basic name is derived from the Old English mynster, predictably 'the monastery or large church'. The addition is a reference to the Luvel family, lords of this manor in the thirteenth century. Indeed the priory was founded by Maud, the widow of William Luvel, in 1206 and which was linked to Ivry in Normandy.

This parish also has a Little Minster, recorded as Minstre in 1086 and Mynstre Parva in 1316, which also refers to 'the monastery' and is smaller in comparison to the main place. During the fifteenth century the place is recorded as Mynstre Laundell, a reference to family of John Laundell. Doubtless the similarity in the two family names was significant in the evolution of this name as simply 'Little'.

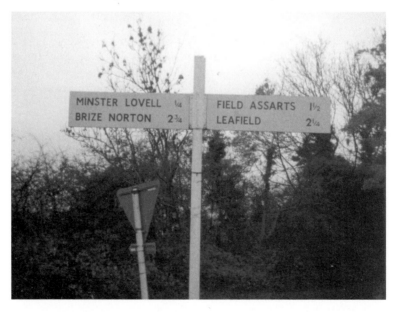

Minster Lovell road sign.

Mixbury

Listed as Mixeberia 1130, Muxiberi Aregnes 1220, Mixbur 1265, and Mycebury 1428, this name comes from the Old English mixen literally meaning 'dunghill' and burh 'fortified place'. The record of the early thirteenth century marks the arrival of Milo de Harensis, granted land here in 1170 by Bernard de St Walery. It seems the sizable midden here was a remnant of much earlier occupation and will be connected with the name of Fulwell, from 'the foul stream' which runs past both. Today the stream runs clear although it could hardly be considered drinkable, which was probably all the name signified.

Not all the names in the area of this parish are less than complimentary, a look at the field names would suggest this to be a very pleasant place to live: The Coney Gate was named for the 'path to or by the rabbit warren'; the Parsonage Meadow would have been church land; and Sweetingtree Hill is named from the sweeting, the name given to 'a small sweet apple which could be cropped earlier than other varieties' but would be of little economic value today owing to its size.

Mollington

A parish which has fluctuated between being part of Warwickshire and Oxfordshire. The name comes from Old English and tells us this was 'the farmstead of the family or followers of Moll'.

Mongewell

A name which has changed little over the centuries – Mundingwillae 970, Mongewel 1086, Mungewell 1184, Mongwell 1408, and Mundgwell 1646. These all come from Old English ing - wielle following a Saxon personal name and giving '(place at) Munga's spring or stream', here the ing carries no meaning but only appears through incorrect usage as a connective syllable.

Mollington's recently erected village sign.

Chapter Thirteen

N

Nettlebed

Unusually the earliest record here is exactly the same as the modern form, Nettlebed is recorded on a document of 1246. The name is Old English and has changed little from the original netele-bedd which tells us this was '(the place in) the valley where nettles grow'. Nettles, as doubtless many of us have found to our discomfort, grow in a great number of places. Thus we can expect this particular valley to have been overgrown by the plant.

Crockerend Common took its name from the Old English crocca 'pot' and aern 'house' which stood here, more easily said to be 'the building where pots were made'. Soundess House and Soundess Farm have a common origin, most easily said to be from 'sandy soils'. However the plural is unusual and may well suggest the name was brought here as a family name, although there are no written records to support this. Joyce Grove is the only remnant of the farm of that name, not a female but a family name. A Freeboard is farmland which was originally outside the estate of the lord of the manor, therefore outside their control and not subject to taxes. The Mean Field takes its name from gemeane or 'common land'.

Newington

In 1045 it was Niwantun, in 1086 Nevtone, in 1276 Niwenton, and in 1285 Newentone. This is, as it would seem, from 'the new farmstead'. This would suggest there was an older original settlement for these people, which was probably not far from here. However there is nothing recorded as the point of origin of these people will never be known.

Locally is Berrick Prior, named from 'the barley farm' the addition is to show possession by the Prior of Canterbury and to distinguish it from Berrick Salome. From the Old English holh-cumb comes 'the hollow valley' and there are two such

named places Great Holcombe and Little Holcombe. However there is a third name of the same meaning and may be simply a corrupted version and seen as Hollandtide Bottom.

Here the local is the Rose Revived Inn, a floral name which lends itself well to the 'reborn' image of the pub in its new guise.

Newnham Murren

Whilst the hamlet has largely been absorbed by the parish of Crowmarsh Gifford, it does retain an identity and is treated separately. With records of Niwanham 966, Neuueham 1086, Newenham 1184, Neuham 1219, and Newnham in 1461. Here is a place name derived from 'the new homestead or hamlet', to which was later added the name of the Morin family, Richard Morin is known to have been here in the thirteenth century. However the addition is not seen before 1533 as Newnam Moryn and mistakenly given as Newnham Warren in 1797.

English Lane marks the site of the manor of Richard English.

Newton Purcell

A name found as Niweton in 1198, Newenron 1213, Newinton 1225, Newinton Purcel 1220, Nywenton 1278, and Nywentone Purcel in the early fourteenth century. This tells us it was the niwe-tun or 'new farmstead' which was held by a member of the Purcell family by 1198.

Local names include Shelswell, which could be from either 'Scield's spring or stream', if the earlier forms are accurate, or the first element may be sceald giving 'shallow stream'. Barleyfields is another which has become something different from its begininngs. Early forms show this is burh-leah-feld, 'the open land near the moated woodland'. Of course the moat was never designed to surround the wood, nature has simply reclaimed the land. The addition of Purcell was to differentiate from Newton Morrell, 'the new farmstead by the spring in the fen'.

Noke

The evolution of this name is unusual and worthy of examination. A clue as to the odd history of this name is seen when comparing the record of 1382, where the name is given in the modern form of Noke, with the record in Domesday in 1086 of Acham. This came from two words, Middle English atten and Old English ac. If we know this second element means 'oak tree' the name begins to make more sense for atten-ac speaks of '(the place) at the oak trees'. Over the years the first part was dropped and yet the 'n' became associated with the second element rather than the first – a very regular occurrence when the following element begins with a vowel.

Field names in the parish are highly descriptive: Indigo Mead is 'a dark coloured meadow'; Log Field and Log Mead were more likely where logs were stored rather than cut for the supply would have dried up long before the names had become established;

however the name of Opposite Close does not make it clear what it is opposite to, while Back of the Town is only helpful if you know where the front is.

North Aston

Named to distinguish this place from Middle Aston and Steeple Aston, this one is certainly north of the other two 'eastern farmsteads'.

North Hinksey

Separated from South Hinksey by a mile of the A34, bypass the basic name here has a first element which has two possible meanings. Listed in the tenth century as Hengestesige, this is a Saxon personal name with the suffix is the Old English eg and giving 'the dry ground in marshland of a man called Hengest'. However this personal name is also the word for a stallion, hence probably used as a nickname, in which case this would give 'the dry ground in the marsh of the stallion'. If this latter origin is the correct one, the horse in question must have been a truly magnificent beast.

The local is the Fishes, its sign of two perch and three pike showing the early landlords to be fishermen. In recent times the sign has been interpreted in a more jocular light, said to represent the the locals who 'drink like fishes'.

North Leigh

Even without the dozen or so early forms of this name we have available, it would be easy to see this as coming from leah 'the woodland clearing'. The addition, first seen in the early fourteenth century, is to distinguish it from South Leigh.

Ashford Bridge is a rather corrupted local name which in fact comes from Old English aesc-ofer or 'the higher place of the ash trees'; Sturt Copse conveys a message of this being 'the small woodland on the tongue of land'; Wilcote is derived from 'Wifel's cottages'; Perrottshill Farm was named after the mid-eighteenth century lord of the manor.

Northmoor

A name derived from Old English mor or 'marsh', and recorded as such in 1059. It is not until 1200 that the 'northern marsh' is first seen, when it is also said to be 'the marsh associated with St Denis', the dedication of the church.

Bablock Hythe has three elements, a Saxon personal name with lacu and hyth. The place name's earliest records speak of 'Babba's stream', to which 'landing place' was added by the eighteenth century. Also here is Moorton or 'the farmstead of or in the marsh'. Ramsey Farm features a place name derived from hramsa-ieg or 'the island where wild garlic grows'.

One local pub continues this watery theme as was named the Ferryman Inn after a former resident.

North Newington

This is another example of 'the new farmstead', this Newington lies to the north of its namesake.

If the story behind the place name is less than inspiring, that of the local here is truly a family effort. This inn was formerly known as the Bakers Arms, as a business it was ticking over but the potential was here for anyone who had the necessary drive and desire. One of the first things they had decided was that a new name was required, what was needed they had no notion other than it had to be very different. Another obvious failing was the old barn, now an exquisite restaurant and accomodation, when they arrived it was used solely for storing wood. When fuel for the fires was required it meant a visit to the old barn and every time the door was opened in the evening the resident barn owl would fly silently, so close past their heads they could feel the wind it created. Although they did eventually become accustomed to the bird it was here the name was blurted out when the door opened – 'That blinking owl!'

This is not the end of the tale for the Blinking Owl public house required a sign. The task was given to the one daughter, both the sisters were keen and talented artists and delighted in producing the sign of the public house which is the epitome of a family business.

The Blinking Owl, North Newington.

North Stoke

A name recorded in Domesday as Stoches, which undoubtedly comes from the Old English and telling us this was an outlying place and an agricultural outpost. The modern addition requires no explanation, yet this was not seen until 1479 and is just

one of several names which are recorded for this Stoke – Stokebasset shows it was the home of Thomas Basset and his wife mentioned in a document of 1181; Stoke Moeles is named to mark the granting of a rabbit warren to produce food and an income for Roger de Molis.

Field names here include a name from forth, which means 'front, forward' and an element which is invariably seen, as indeed it does here, as The Forty making it seem to be a numerical value when it is really geographical. Hatchet Piece comes from haecc-geat both of which refer to the path which ran to or past this small area; The Linches is derived from hlinc describing 'a bank or slope'; Picked Close is from piked 'a triangular piece of land'; Little Pillands comes from pyll, 'the area of a small stream'; Smoke Acre is from smoke and a common field element which always refers to a 'taxable region', although it is rare to discover the reason for the taxation; this is not the case with Milking Path Piece, where the meaning is clear and the name a delight; while the name of Newfoundland is one suggesting this is the most remote part of the village.

Nuffield

This name is recorded as Tofeld in 1181, which undoubtedly comes from toh - feld and tells us this was 'tough (ie difficult to work) open land'. From the fourteenth century the name is recorded, and presumably vocalised, with the initial 'N'. Perhaps this was due to an unrecorded atten 'at the' which eventually was reduced to a single letter, as was the case with Noke above.

A name like Gangsdown Hill comes, oddly enough, from 'Gangwulf's valley' and then the name was transferred to the hill above. However Groveridge Wood means what is seems 'the grove on the ridge of land'. Hayden Hill refers to 'the hill where hay is gathered'; Hunterscombe End tells of 'the valley of the huntsmen'; with Mays Farm takes its name from 'the mersc or marsh'.

The Crown shows a loyalty to the throne of England, while doubling as a simple yet attractive sign.

Nuneham Courtenay

Domesday records the name as Newham, which comes from Old English niwe - ham and meaning 'the new homestead'. The element 'new' is revealing, for it shows there was an older settlement (which probably gave the place its name) where the first inhabitants of Nuneham originated. The addition is not seen until 1320 when the record shows Newenham Courteneye, this further addition a reference to the Curtenay family who were certainly here by the thirteenth century if not before.

Nineveh Farm takes its name from the remoteness name of the village, and is recorded from the late eighteenth century. Alder Hill Plantation is a field alongside the hill where alder trees grew; Coblers Nob is nothing to do with shoes and cobblers, it is a region where the soil contains some rather large stones or cobbles; Hockell comes from 'the spur of land on by the hill'; Kidney Plantation refers to the shape of this field; Poughley Farm is named from the family who travelled here from Poughley in Berkshire, a distance of approximately 15 miles.

Chapter Fourteen

Oddington

Listed as Otendone 1086, Otindon 1220, Otigdon 1278, and Otyngdone 1285, this place name comes from the Old English telling us this was 'Otta's hill'.

Locally we find Brookfurlong Farm, which really is ' the place at the brook running for one furlong (210 metres) through the farm'; and the names of Berry Fields and Hog Hole are equally as literal.

Over Norton

A name recorded as Parva Norton 1213, Spitulnorton 1217, Caldenorton 1218, Wolde Norton 1268, and Overenorton in 1302, which shows there was a great deal of alternative names for this place during the thirteenth century. Today the name speaks of 'the higher north farmstead'; however in earlier days it could have become 'the cold north farmstead', 'the open land farmstead', 'the north farmstead hospital', or 'the little north farmstead'.

Oxford

The county town was recorded as Oxnaforda in the 10th century and as Oxeneford in 1086. This is an Old English name from oxa-ford and referring to '(the place at) the ford used by oxen'. To give the name the use of the ford by the cattle must have been over a significant period of time, furthermore there must have been more regular crossing of animals at this point than people. This would indicate the animals were being herded across to make use of fresh pasture or to return to cattle sheds.

Various roads dotted around the city are named after places across the country. These were named after pockets of land held by St John's College and include Bainton Road,

Bardwell Road, Belbroughton Road, Bevington Road, Bradmore Road, Chadlington Road, Chalfont Road, Charlbury Road, Crick Road, Farndon Road, Fyfield Road, Garford Road, Kingston Road, Leckford Road, Linton Road, Northmoor Road, Polstead Road, and Warnborough Road.

Prior to the roads being cut the land had already acquired a name. These earlier names are often taken for the names of the roads. Beaumont Street takes its name from Beaumont Palace, built in the twelfth century by Henry I outside the town. Norham Gardens were once part of the Norham Estate. Holywell Street tells us there was a holy well near the church of St Cross which is now buried under the concrete of modern development, while Manor Road is named after the Holywell Manor, a medieval home rebuilt in 1516. Hythe Bridge Street leads to the Hythe Bridge, itself named after the hythe or landing place on the Thames here, which had existed since at least the thirteenth century. Littlegate Street takes its name from one of the seven medieval gates of the city, which Longwall Street ran along the length of the city wall.

Oxpens Road ran past the farm where oxen were kept. Paradise Square and Paradise Lane refers to the apple orchard here which belonged to the Penetentiary Friars, a reference to the Garden of Eden and its link to apple trees. Plantation Road refers to the field name still found quite commonly today, while the oddly named Squitchey Lane refers to the squitch or quitch grass which grew here before the developers moved in.

Broad Street was wider than contemporary ways, previously known as Horsmongeres-streta from the early thirteenth century as being where horses were sold. Carfax is one of the most famous of Oxford's street names, it is derived from the Latin quadrifurcus and the French carrefour meaning literally 'four ways' and describing a crossroads. The Plain is cut on an open level region. New Street is hardly 'new' since it dates from the eighteenth century, however it is regarded as being the first new road constructed in the city since the time of William the Conqueror.

Market Street was the site of a covered market, opened in 1772 and previously known as Cheynelane for the chain across one end used to deny access to traffic. A similar barrier was employed at Cheney Lane. Cornmarket tells us what commodity was sold here. Museum Road is named after the University Museum, New Inn Hall Street the college which was eventually absorbed by Balliol College in 1887, and Parks Road and Park Street allude to the university parks. St Bernard's Road is a reference to the college from which St John's developed, itself remembered by St John Street.

The Bridge of Sighs is a famous landmark in Venice as well as the name of a covered walkway in Oxford. Folly Bridge recalls the tower which stood halfway across the bridge, originally known as Bachelor's Tower, then Friar Bacon's Study and finally simply The Folly. Bulstake Bridge was probably named after the stake to which bulls were tethered prior to baiting, a blood sport which was banned many years ago. Magdalen Bridge takes its name from the college and is recorded in 1661 as East Bridge commonly called Maudlin Bridge.

Other street names are found with religious origins. Friar's Entry provided access for the Carmelite friars to the church of St Mary Magdalen. Gloucester Green is named after Gloucester Hall, itself named for its historical links to Gloucester Abbey, which was a Benedictine monastery founded here in 1283 and is now Worcester College. Streets named after the dedication of a church on the site include St Aldate's, St Giles and St Helen's Passage. Jack Straw's Lane may also be named after a religious figure, a priest who came to prominence during the Peasants' Revolt of 1381, although it is

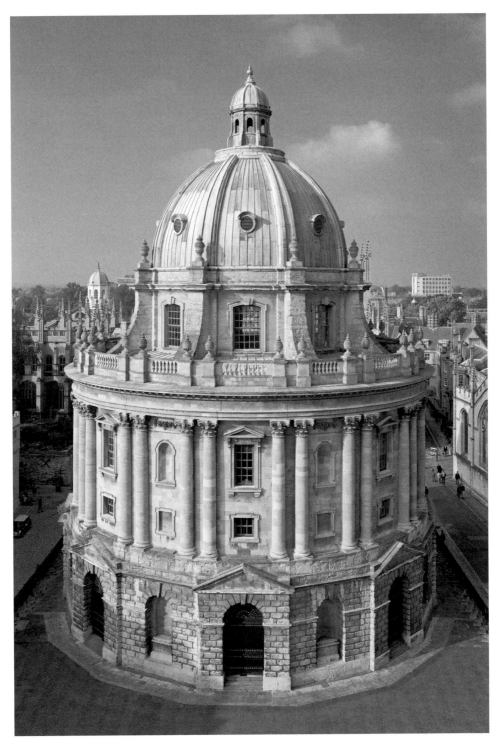

The Radcliffe Camera in Oxford.

equally plausible to suggest it refers to a wealthy farmer of the same name who lived on Headington Hill.

Individuals who have given their names to streets may not necessarily be former inhabitants, yet they would certainly have had some link to the city. Davenant Road remembers the man who became poet laureate in 1638, Sir William Davenant. The Morrell family were a family residing at Headington Hill Hall, they made their name in brewing and gave it to Morrell Avenue. Queen Street was cut and named in honour of the then queen, consort of George III, Queen Charlotte.

Places which are remembered include Walton Street, which led to the manor of that name. However High Street, known as Eastgate Street until the seventeenth century, refers to its long time importance and not its elevation above sea level. A new source for modern street names was provided by the enthusiastic town twinning of the latter half of the twentieth century. Bonn Square is clearly named after the German city with a history as long as that of Oxford.

Obviously a famous university city will have names reflecting this. Frewin Court is named after Richard Frewin, Professor of Ancient History at Oxford in the 18th century. Frewin Hall, also named after the same man, is now a part of Brasenose College. Jowett Walk recalls Benjamin Jowett, Master of Balliol College, the street was previously known as Love Lane as it was either a favourite haunt of courting couples or possibly a red light district. Magdalen Bridge is named after the landmark at the west end of the river crossing, Magdalen College. This was where Josiah Pullen (1631-1714) served as vice-president and who was also a local vicar, giving his name to Pullen's Lane. Pusey House gave its name to Pusey Street, the building serving as both a chapel and an Anglican theological library. Logic Lane was named after the school of logicians housed at the end of this lane.

Two names taken indirectly from its status as a university city are Great Clarendon Street and Little Clarendon Street. The name comes from Clarendon Press, which was located in the Clarendon Building and is the printing house of Oxford University Press. The name of the building, the printing company, and thus both streets, was taken from publication of History of Rebellion by Lord Clarendon and published in 1704.

Trade names used as street names are often thought to show where that particular business was situated. However this is a common mistake, for many times it refers to the trader's residence and not his place of work. This would be true for both Brewer Street and Fisher Row.

Thames Street leads to the river, Turl Street once had a turnstile of other revolving mechanism to control entry rather than a standard gate. Catte Street tells us it was where feral cats were known to congregate, obviously with a reliable food source available for some time. However it was changed to Catherine Street when this was thought to be a pet form of that name, yet the mistake was pointed out and the original name, with the medieval spelling, returned.

Old public houses have given their names to the streets here. Bear Lane is one, although any record of the Bear Inn being directly linked with this road has yet to be traced. The inn which stood on the site of the Museum of Oxford is remembered by the name of Blue Boar Street. Hollybush Row is named after the seventeenth-century inn of that name, while the Ship Inn is likely a misnomer and refers to the sheepmarket which was a regular occurrence and virtually on the doorstep.

There is also Magpie Lane, named after the seventeenth-century alehouse, which was previously known as Gropecuntelane and first recorded in 1230. This is not as bad as it may seem, it refers to a very narrow passage which, especially in darker hours, it would have been necessary to grope one's way along

The current pubs and bars of Oxford exhibit names which are as imaginative as any city in the land. A welcome is promised in the name of the Dew Drop Inn; a similar sentiment is conveyed by the Jolly Postboys; while a less obvious feeling of well being is promised by the Cape of Good Hope; the Talkhouse is simply begging you to call in for a chat; and the Grapes advertises the wine available within.

The founder of the car manufacturer which bears his name is remembered by the William Morris; the Chester Arms recalls a family with extensive lands held across the land and who originated in Derbyshire; the Royal Blenheim is named for the ancestral home of the Dukes of Marlborough; the Osney Arms is a place name meaning 'Osa's island' and was taken as a family name which is represented by a lion rampant surrounded by eight bells; the Kite Inn at Osney is a bird which is an impressive site in flight and a good subject for a sign in an area where it was once common; another bird of prey is found at the Eagle & Child, although here it is the symbol of the brewery of Charles Wells of Bedford; Duke of Cambridge is a title sometimes conferred on members of the royal family; the Britannia Inn is a patriotic name; and the Black Swan is an heraldic symbol for a rare individual (the Austirlian bird was unknown at the time).

History is an important source, giving us the Port Mahon, captured by British forces in 1708, the Minorcan action was probably witnessed by the first landlord to hold this place. The Hobgoblin is a name from folklore, although the name comes from the most famous brew of the Wychwood Brewery.

Trades such as the Gardeners Arms, an obvious reference to a horticulturist; the Watermans Arms, a member of the Worshipful Company of Watermen and Lightermen, and one who worked closely with boats; the Turf Tavern would have been where to place a wager before betting shops were legalised; the Brickworks recalls a local place of employment; the Isis Tavern points to the nearby river, as does the Folly Bridge Inn.

The Oxford Blue is named after the award for representing the university at sport; the Perch reminds us of the coarse fish found in the river; the Harcourt Arms is named after an early development; the Angel & Greyhound tells us this was a staging post; James Street Tavern takes its name from the road; Jericho Tavern comes from the place name, as does the Bullingdon; the Marsh Harrier would have been at home in the area.

A university city has provided the name of the Antiquity and Corridor, fitting names for Oxford. As a centre of learning the literary references abound in names such as: Jude the Obscure, the last novel of Thomas Hardy and Far From the Madding Crowd, the fourth by the same author; the Shelley Arms commemorates the poet Percy Bysshe Shelly (1792-1822).

Jericho is a district of Oxford and was outside the old city wall. Since before the Middle Ages the furthest flung corner of a parish was often given a name which suggest, albeit jokingly, its distance from the main area by naming it after some far flung corner of the world. Normally the name chosen was relevant to the period, perhaps due to the discovery of a new land or colony. However here it seems to have been deliberately chosen for its religious connections, although exactly why is unknown. The Old Bookbinders Ale House was named to reflect the fact the Oxford is a university city.

Another district name is that of Grandpont, listed as Grantpunt in 1180, Grauntpount in 1140, Magno Ponte in 1240, and Graundpaunte in 1367. It is a French name meaning 'the great bridge' and referring to the causeway, a series of crossings linked together to form one continuous crossing of ditches, drains and brooks.

Oxfordshire

The county takes its name from the city of Oxford with the addition of Old English scir. This term literally means 'district' and, while it is not referred to before the eleventh century, the county certainly existed prior to this and it is simply that records have not survived.

Oxon

In 1974 the government announced a nationwide reorganisation of county boundaries, the greatest administrative upheaval of its kind for around a millenium. As a result of these changes the county name was changed to Oxon, which has no etymological value for it is simply an abbreviation of the Latin version of the name, Oxonia. It is no surprise to find the Romans simply gave an existing name a Latin twist, for when it came to naming places they had virtually no input.

Chapter Fifteen

P

Piddington

This is from Old English or Saxon for 'Pyda's farmstead', and is listed as Petintone in 1086, Pedyngtona in 1151, Pidentuna in 1152, Piditon in 1203, Padinton in 1235, Pridington in 1278, and Podynton in 1428.

Corble Farm come from the old terms corbin for a 'raven' with snaed-leah, giving a meaning of 'the clearing in the wood of the ravens'. Muswell Hill describes 'the mossy spring', from meos-wielle and an unconfirmed site of a Roman encampment. There is a field marked as Broadhurst Gore, a name telling us it was 'the grove of the broad wooded hill', and Mad Croft which refers to 'the meadow field'.

Pishill

Listed as Pesehull 1195, Piselee 1200, Pishulla 1205, Prishull 1278, and Pyssehulle 1284, this name comes from Old English peose-hyll or 'the hill where peas grow'.

Local names include Stonor, where all the early forms point to Old English stan-ora, '(place at) the stony slope'. Upper Assensdon, Middle Assendon and Lower Assendon are three regions named from the same feature, which has been defined as 'Assa's valley'. There is no language barrier from this being the 'ass' rather than the personal name, however there is no reason to suppose the ass was here in any great numbers and thus the name is much more likely. Doyley Wood is a name not found before 1840, yet the family who gave their name to the place were here in the thirteenth century; John Doyley in 1275 and Richard d'Oylly in 1275.

Prescote

Also referred to as Prescote Manor and Upper Prescote, the basic name is a common one and speaks of 'the priest's cottages'.

Pyrton

Listings of Pirigtune 987, Piritune 1086, Pyrynton 1184, Pirentone 1242, and Puriton 1268, all point to an origin of Old English pirige-tun or 'the farmstead of the pear trees'.

Here we find the region known as Clare, from claeg-ora and giving '(place at) the clay slope'. Edgington stands on the parish boundary with Watlington and it tells us this is 'the boundary settlement'. Golden Manor was known by this colour many years before a manor house was built here, it comes from gold-ora and means 'the slope where the golden flowers grow'. Listed as simply Stangedelf in 1002, the 'stone quarry' from Old English stan-delf is seen on modern maps as Upper Standhill and Lower Standhill. Ashbys is a name derived from the occupants in the thirteenth century, John de Esseby and John Desseby. Burnt Bake is a field name describing where an area had been cleared by fire and the resulting debris chopped up to fertilise the soil. Great Clink is a corruption of 'cling' and a term used to describe sticky soil.

Chapter Sixteen

R

Ramsden

This name is recorded as Rammesden in 1246 and Ramesden in 1307. This comes from Old English hramsa-denu and telling of 'the valley where wild garlic grows'. The name was later applied to the nearby heathland as Ramsden Heath in 1641.

Locally we also find Hulwerk, a region named after the de la Helworck family, here by 1250.

Ray (River)

A quite common river name, although it appears with a number spellings. It has as varied a history, from an etymological perspective, as any river in the land. In 845 it was Geht, in 983 Giht, in 1185 Ychte, in 1186 Ikam, and in 1298 Yhst. These are doubtless from a Celtic or British river name related to the Ieithon in Wales and the Ythan in Scotland. The root here is a word associated with the Welsh iaith literally 'language' but would have been used in the sense of 'talkative' and readily understood when given as 'babbling brook'.

Ridge Way

One of the oldest routes in the county has one of the most obvious names. In truth it is probably a collection of ancient paths which have joined to create one longer one.

Rotherfield Greys

A name which has been found with almost fifty different forms over the centuries, including Redrefeld 1086, Radulfi Murdac 1194, Retherfeld 1240, Rotherfeld 1275,

Rotherfelde Grey 1316, and Rutherfeld Grey in 1362. This comes from the Old English hryther-feld 'the open land grazed by cattle'. The addition seen in the twelfth century of the family name of Murdac is the last time these people are mentioned, thereafter it is the Grey family.

Locally we find Padnell's Wood from 'Peada's healh or corner of land'; Satwell is named from a family who came from Sotwell in Berkshire; Witheridge Hill began life as 'the ridge where willow trees grow'; Greys Court and Greys Green take their name from the holdings of Walter de Grey, former Archbishop of York. Field names include The Five Pound Piece, a reference to the annual rent; Chauntry Lands belonged to the local church; The Warren was renowned for the numbers of rabbits; and Snakes pightle was 'the corner of land where snakes abound'.

Rotherfield Peppard

As with the previous name this comes from 'the open land grazed by cattle'. Here the lords of the manor were the Pipard family, who held much land and were based at Wallingford.

Local names include Silgrove Wood or 'willow grove woodland'; Colmore Farm from 'Cola's pool or mere'; Sedgehill Spring reminds us this was once 'Secg's spring', which also gave its name to Sedgewell Road; The Gore comes from gara or 'triangular piece of land'.

Rousham

A name recorded as Rowesham in 1086, Roduluesham in 1130, Roulesham in 1202, Rolesham in 1220, and Roghelesham in 1308. It comes from Old English and describes 'Hrothwulf's homestead'.

Chapter Seventeen

S

Salford

Records of Saltford in 777 and Salword in 1086 both point to Old English sealt-ford. This undoubtedly refers to the ford lying on one of the great saltways which crossed the land. Nearby Rollright had salt rights in Droitwich in 1086, and we can safely assume the salt would have been transported from there.

Sandford on Thames

This name is found in 1050 as Sandforda and in 1086 as Sanford. Both are clearly from Old English sand - ford 'the place at the sandy ford'. The addition is obviously from its position on the Thames, the etymology of which is discussed under its own listing.

There is a Minchery Farm here, named from the Benedictine nunnery. While the image of the Catherine wheel, a firework which has endured for centuries, is a simple one. The spinning firework itself is named to commemorate St Catherine of Alexandria, who was martyred when tied to such a wheel. This is not as macabre a choice for a pub name as it may seem. Adopted by the Knights of St Catherine of Mount Sinai as their badge, it appeared as a pub sign to show it was a place to contact this order who would then provide protection for pilgrims to Jerusalem.

Sandford St Martin

Again from the same Old English sand-ford, the name was recorded as Sanford in 1086. The addition is from the dedication of the church, to St Martin of Tours.

Local names in the parish include Grove Ash Farm refers to 'the copse of ash trees'; Ledwell takes its name from hlyd-wielle or 'the loud stream'.

Sarsden

The river name here is taken from the place, a process known as back formation, and is easily seen for the Sars Brook. This place name is recorded as Secendene 1086, Cercheden 1173, Cercendone 1180, Carceden 1204, and Certendone 1285. Here the modern form has been greatly corrupted since the sixteenth century and comes from Old English circan denu and referring to 'the church in the valley'. One local name of No Man's Land refers to 'land on a boundary'.

Shenington

A name derived from Old English or Saxon scienan-dune 'the beautiful hill'. However there is a possibility that this comes from a personal name and refers to 'Sciena's hill'.

Shifford

Records of this name include Scipford 1005, Scifort 1091, Schiford 1159, Sipford 1198, and Scheford in 1268. This is undoubtedly from Old English sceap-ford or 'the ford used by sheep'. This tells us a number of things. We can deduce that sheep were here in abundance, were frequently crossing the river to graze both sides, and this lifestyle was around for a very long time in order to become the name of the place – a general history, and all simply from defining the name.

Shillingford

Early records of this name are limited to a single entry in a document of 1156 as Sillingeforda. Because of the lack of alternatives it is difficult to decide between two equally plausible definitions. The first element may be a personal name which, followed by Saxon inga-ford, would tell of 'the ford of the family or followers of Sciella'. However the first part could be an Old English stream name Scielling, this informing us this was '(the place at) the ford crossing the noisy one (stream)'.

The water reference is also seen in the name of the local pub. The Kingfisher is an iconic bird with its dazzling plumage. It was once also known as the halcyon, which is still used in the phrase 'halcyon days' a time of great prosperity and joy.

Shilton

In 1044 we find this place recorded as Scylftune, an almost perfect reproduction of scylf - tun, the farmstead of a shelf, a ledge of land'.

Local names in the parish include Hen and Chickens Plantation, which, as could be guessed, has nothing to do with our avian friends but is a dialect which refers to at least eleven different kinds of plant. While we have no idea why any plant would be given such a name, the 'tail-shaped piece of land' is an obvious description of Sturt Farm.

Shiplake

Recorded in 1163 as Siplac, this is clearly from the Old English sceap-lacu or '(place at) the sheep stream'.

Binfield House is named after 'the field of bent grass', that is it remains uncut and collpased under its own weight; Crowsley Park is named from 'Croc's woodland clearing'; Lashbrook is a stream name which describes 'the stream flowing through boggy land'; Shiplake Cross is named after Avelina de Cruce, who owned land here in 1273; Great Gog and Little Gog have the dialect word for 'bog'; Kit Keys refers to the region of ash trees, the 'keys' being the fruit of the ash tree; Monkey Corner refers to 'the land where young hares are seen'.

The Plowden Arms here may be taken from a surname or a trade name. Plowden is an early form of 'ploughwright' or maker of ploughs.

Shipton on Cherwell

As with the following name, the basic place name here tells us of 'the farmstead of sheep'. The addition is from the river name and is discussed under that name.

Shipton on Cherwell, the river in flood and the flooded regions have frozen over.

Shipton under Wychwood

As with other places nearby, the addition refers to the forest which once covered much of the land hereabouts. Its name is derived from 'the wood of the tribe called Hwicce', a record from 840 gives the name as Huiccewudu.

The basic place name is found across the southern counties of England. It is derived from Old English sceap-tun, meaning 'the farmstead which specialises in sheep'.

The local here is the Red Horse Inn, an image and name taken from the coat of arms of a family associated with the place.

Shirburn

A name which has been taken from its water course. From the Old English or Saxon scir-burna, this settlement began life as the '(place at) the bright stream'. It is found as Scireburne in 1086, Schireburna 1194, Shyreburne 1252, and Sherborn 1523.

Knightsbridge Farm takes its name from cniht-brycg, not exactly what it may seem for this is 'the bridge of the young men' for the term originated as a 'servant of the king' suggesting a potential fighting man. Whitfield Close takes its name from the neighbouring parish of Wheatfield and, somewhat ironically, is a street name closer to the meaning of 'white field' that the modern name of the place. Cats Brain Ground is an unusual name with quite odd beginnings. It describes the soil, a coarse texture of clay with plenty of small stones, said to resemble the texture of a feline brain. Rod Eyot is the 'island clearing in a forest', Long Loved Land most likely proved a reliable piece of land feeding a number of generations of the same family, while the Shoulder of Mutton is a common field name and a reference to its shape and not to any sheep that may have grazed here.

Shorthampton

Recorded as Scorhamton 1227, Sorthampton 1232, Schormanton 1246, Scorthamptone 1262, Shorthamtone 1291, and Schorthamton in 1293, this comes from short-ham-tun meaning 'the short farmstead estate'.

Locally we find names such as Chilson from cild - tun and meaning 'the farmstead of the young noblemen'; Pudlicote House takes its name from the earlier name of 'Pudel's cottages'; Thorngreen Copse is named after 'the small wood of thorn bushes'; Lower Arbour and Upper Arbour from eorth-burh 'the woods by the earthwork'; and Sweedentree Plain refers to the 'flat area of the sweeting tree', a small apple which matures earlier than other varieties.

Shrivenham

Two records of this place provide information, from 950 comes Scrifenanhamme and from 1086 Seriveham. Old English scrifen-hamm forms the basis of the name, which tells us of 'the river meadow given by a decree' in this case to the Church.

Shutford

The earliest surviving record is from 1160 as Schiteford. It is derived from the Saxon and describes 'Scytta's ford'.

The George & Dragon refers to England's patron saint, a knight from around the third century whose deeds are shrouded in mystery and about whom virtually nothing is known. His legendary battle with the dragon, thus bringing Christianity to those who were under the monster's control, does not appear until hundreds of years after his death. This tale has probably done more harm to his credibility in the modern era, making him as legendary as the creature he is said to have destroyed.

Sibford Ferris

Here the basic name is recorded in Domesday in 1086 as Sibeford. There is no doubt this comes from Old English and speaks of 'ford of a man named Sibba'. The addition has no surviving records earlier than the eighteenth century, however the name certainly existed well before this for it refers to the de Ferrers family who were known to be here from at least the thirteenth century. The addition is to differentiate from Sibford Gower, which is discussed in the next entry.

Sibford Gower

Another 'ford of a man called Sibba'? Not exactly, for this and Sibford Ferris are named after the same ford, a river crossing between the two places which are only 500 yards apart. Here the manorial family were the Guhers, shown to be here at least by 1280 for their name is given in the record of this place as Sibbeford Goyer.

The Wykham Arms is named after the nearby village of Wykham approximately five miles to the east.

Within the parish is the name of Burdrop, which is derived from burh-thorp or 'the hamlet near the outlying farmstead'. Ditchedge Lane follows the line of the drainage ditch, while Temple Mill is named from the Knights Templars who were based in neighbouring Sibford Ferris.

Somerton

This is a name also found in Norfolk and Somerset. It is recorded as Sumertone in 1086 and is derived from the Old English sumor-tun and, as the pronunciation of the name would suggest, describes 'the farmstead used in summer'. It would have been common to find an outlying settlement used only during the growing season, to have travelled home every evening would have wasted time and left the grazing animals vulnerable. The shelters would have remained unoccupied during the winter months for some time in order for the name of the place to stick, although eventually the settlement would have become permanent.

Sonning Common

The addition points to other places named Sonning to the south, whilst also telling us this was common grazing land. First recorded in 1167 as Sunninges, this comes from a meaning of '(the place of) Sunna's people'.

Russett Close is named after the kind of apple grown here before this and Orchard Avenue were cut.

Sonning Eye

Recorded in 1285 as simply Eye, it first appears with the addition as recently as 1761 as Sunning Eye, a name which tells us this is 'the island near Sonning'. The second element is from Old English eg or 'island', a description of dry land in a wetter region rather than the modern idea of a being permanently surrounded by water. See Sonning Common.

Sotwell

Although often listed with neighbouring Brightwell, it is a separate village and shall be treated as such. The name is listed as Suttanwille in 945 and Sotwelle in 1086. This comes from a Saxon personal name with the suffix wella and giving '(the place at) Sutta's well or stream'.

Souldern

A name which is recorded as Sulethorne in 1152, Solthorne 1197, Shulthorne 1236, Saldern 1389, and Showldren in 1539, a name which comes from sulh-thorn and telling us of 'the thorn bush in a gulley'.

Local names of interest include Chisnell Farm, which takes its name from cisen-hyll or 'the hill with gravelly soil'. Ploughley Hill has an oddly shaped tumulus which gives it a literal name of 'baggy tumulus' and describes it as 'bell shaped', the name of Ploughley was given to the Saxon hundred in this region.

South Hinksey

A mile away from North Hinksey along the A34, as discussed under the entry for that place, this is either 'the dry ground in marshland of a man called Hengest' or 'the dry ground in the marsh of the stallion'. It is likely that there was originally only one settlement and the second grew as an overspill or outlying agricultural settlement. It is unlikely that we shall ever know which settlement was the original place of Hengest or the stallion.

When Robert Graves visited the General Elliott in the 1920s, he was so bothered by the locals being unaware who the gentleman was that he wrote a poem about him. George Augustus Elliott (1717-90) commanded the garrison during the Great Siege of

Gibraltar, a combined attempt by Spanish and French troops to take the British outpost during the American War of Independence. The rock was key to the British control of the Mediterranean and defended gallantly from June 1779 to February 1783, during which time the British casualties were just 333 killed in action, 911 wounded, and 536 deaths from disease, well under half of the enemy's losses. When the siege ended and treaties affirmed at Versailles, the general was created Baron Heathfield of Gibraltar.

As well as the poem written by Graves, the siege was the subject of paintings by the American artists John Singleton Copley and John Trumbull. A piece of music composed by Wolfgang Amadeus Mozart, Bardengesang auf Gibraltar; O Calpe! Dir donnert's am Fusse, was published before it ended, once again showing Mozart's favourable view of the British.

South Leigh

Named to distinguish it from North Leigh, this is also 'the place at the woodland clearing'.

Local names here include Homan's Farm, which remembers the farmer Henry Home who was here in 1278, and Tar Farm, after Thomas T'ry who is referred to as leaving a widow in the same document of 1278.

South Newington

The various forms we have all show this is, as we would expect, 'the place at the new farmstead'. The addition is first seen in the late thirteenth century to distinguish it from a similarly named place to the north of here.

Hyde Farm takes its name from hid, a Saxon measurement of land which was approximately enough to enable one family to exist for one year. Clearly the size is secondary to quality and location and therefore the name cannot accurately be said to describe a certain area of land. One of the timeless images of village life is the Duck on the Pond and a simple, yet effective pub sign and name.

South Stoke

One of the most common place names in England, used to mean many things but ostensibly stoc can be defined as simply 'other settlement'. Originally this would have been an outlying area, created for use during the warmer months in order to increase the harvest and provide greater pasture for the livestock. The addition is to differentiate from other places named Stoke, indeed those without an addition are the exception.

Catsbrain Hill is a name describing the soil here, one of clay with small stones, said to appear like the brain of a cat. Dean Farm is named after the Old English denu and meaning 'the valley farm'. Exlade Street is recorded as Egesflade in 1278, the suffix comes from Old English slaed and giving 'Ecgi's valley'. Greenmoor Hill tells us of 'the pool by the green' which has given its name to this nearby hill, and Green Furlong is a field alongside the 'way to the green'. The 'cottages of or by the wood' appears on modern maps as Woodcote; and Horn's Farm was the home of landowner William

Horne, here in 1213, Alexander and Agnes Horn are documented here in 1268. Likewise Nicholas Paiable gave his name to Payables Farm, the same man serving as mayor of Wallingford in 1366.

Field names here include Doctors Gift left by a benefactor of the village for the good of the poor, as was Poors Allotment; Ferney Plat, 'the piece of land covered in ferns'; Sour Croft earns its reputation as 'the muddy field'; Quail Chase was where this bird was trapped for food; and Moon Croft describes the shape of the field as appearing like the crescent moon.

South Weston

A name which is something of a misnomer. From its earliest records this was undoubtedly 'the west farmstead' and, logically, named by an existing settlement east of here. In 1526 the name appears as Southwestone to differentiate from North Weston and is now a reference to its position relative to its namesake.

Field names here include Long Lince Furlong 'the long ridge of over 200 yards' and Lower Mare Furlong 'the long marsh of over 200 yards'.

Spelsbury

During the early eleventh century this name is recorded as Speoles byrig, later evolving to Spelesberie 1086, Speleberi 1220, Spelsberi 1230, Spilleberie 1285, and Spillesbury by 1343. The earliest record here is the closest to the beginnings of 'Speole's burh or earthwork'.

Near here we find other names referring to the ancient earthwork and also complement the hill on which it was built. Dean comes from Old English denu or 'valley' and was the name of a village during the Middle Ages, continuing as the small wood known as Dean Grove. Grim's Ditch, which features either the personal name Grima or the grima or 'mischevious goblin', gave its name to Ditchley, 'the ditch by the woodland clearing'. Fulwell is a common name referring to 'the dirty stream'; and Taston, recorded as Thorstan in the thirteenth and fourteenth centuries, refers to 'Thunor's stone' doubtless a sacred pagan site. Shilcott Wood is named from the ditch which runs through here, referred to by the Saxons as ceole-cot 'the cottages by the throat of the wood' and used in the sense of 'gully'.

Stadhampton

Recorded in 1135 as Stodeham, the name comes from the Old English stod - hamm. This tells us it was 'the river meadow where horses were raised', literally a 'stud'. It will be seen that the modern form appears to also show the element tun, however this is unknown before the nineteenth century and is probably the result of a simple error.

Minor names found here include Ascott from 'the eastern cottage or cottages'; Brookhampton 'the settlement of the water meadow by the brook'; and Camoise Court, a name which sounds French for very good reason, a family who had land here in 1428

as the heirs of domini le Camoys and by a grant from one Richard Camoys, giving lands hereabouts to knights returning home and rewarded for their efforts.

Standlake

A listing in 1155 as Stanlache points to the origins of stan-lacu, an Old English term for '(the place at) the stony stream'.

Local place names here include Gaunt House, which takes its name from the name of John Gaunt and his wife Joan, who are credited with building the property in the latter half of the fifteenth century. Brighthampton is a name which comes from the Saxon for 'Beorhthelm's farmstead'. Rack End is a name which comes from the dialect rack talking of 'a narrow passageway'.

The Black Horse public house has a name taken from an heraldic crest. Today the image is associated with a leading bank, however traditionally it was a nickname for the 7th Dragoon Guards, who had uniforms with black collars and cuffs and would ride black horses whenever possible.

Stanford in the Vale

A common enough place name, hence the addition. It is recorded as simply Stanford in Domesday, from stan-ford it is the Old English for 'the stony ford'. The addition refers to its location in the Vale of the White Horse, the origins of which are discussed under its own entry.

The Horse & Jockey is common pub name, here alluding as much to the chalk figure as to any racehorse.

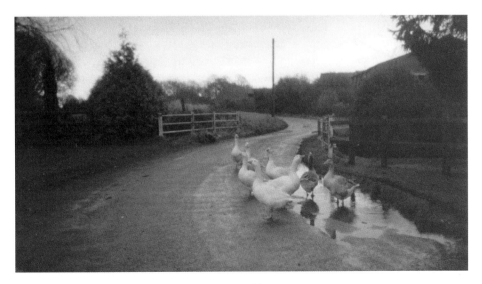

Geese along the way to Stanford in the Vale (sadly not at Goosey!).

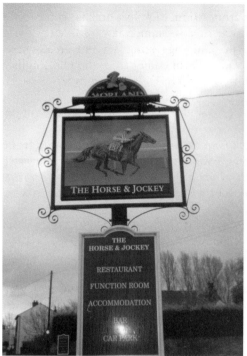

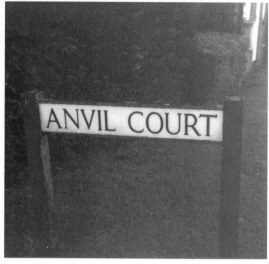

Above: *The location of the blacksmith is given an imaginative name.*

Left: *The Horse and Jockey at Stanford in the Vale.*

Stanton Harcourt

As with the previous name a common name, hence the addition. Here we find Old English stan-tun, giving 'the farmstead on stony ground'. Domesday lists the name as Stantone, the first sign of the addition comes two centuries later as Stantone Harecurt, which acknowledges the de Harecurt family who were here by the twelfth century.

The parish has an assortment of interesting minor place names, including Armstalls from hamsteall or 'the homestead on the corner of land'; Beard Mill, speaks of 'the mill made of boards'; Flexney Farm was desirable for it had natural irrigation in 'the well watered land'; Sutton tells us it was 'the south farmstead'; and Black Ditch contained a particularly dark mud.

The Fox public house here has, along with so many others of this name, used the rascally image of a highly successful and easily recognised omnivore to great effect.

Stanton St John

Listed as Stantone in 1086, as Stantona militum de Templo in 1167, as Stantona Thome de St Johanne also in 1167, Stanton Templariorum in 1195, and Stanton Seynt Johan in 1339. The basic name is stan-tun, 'the farmstead on stony ground', is referred to as being associated with the Knights Templar in 1167 and again 150 years later although there are no records other than this. The present addition refers to the dedication of the church.

Minor names here include Breach Farm from Middle English breche, which tells us it was 'newly cultivated land' when it was first so named in 1788. Menmarsh Farm refers literally to 'the common marsh' and suggesting it is an area where common land borders marshland. Minchincourt Farm comes from the Old English mynecenu referring to a nunnery. The name of Stowford Farm is a corruption of 'the stony ford', from stan - ford, which has evolved over nine centuries. Woodperry comes from pirige and the addition of wudu means this is 'the pear trees by or of the wood'.

Field names here of note include Farthings Gate is misleading, for this comes from 'the fording lane'. There are also two strange field names in A Saint John and Half a Saint John. The basis for this is thought to be syngett and telling us of 'a place cleared by burning', with the corruption due to an association with the dedication of the Church.

Steeple Aston

Aston is one of the most common place names, not surprising considering its meaning of 'the eastern farmstead'. The name appears in 1086 as Estone, from Old English east-tun. With so many examples, additions are the norm. Here it is in the form of Old English stiepel, a reference to it having a church with a noticeable steeple.

Minor names of the parish include Dean Clump and Dean Way which speak of 'the stream in the valley' and 'the way in the valley' respectively. The Holt Hotel began life as a fifteenth-century coaching inn, the name derived from a term meaning 'dweller by the wood or copse'.

Steeple Barton

Standing just over a mile away from the previous entry must have influenced the addition here. It also comes from Old English stiepel, 'a church steeple'. The basic name is a common one, from bere-tun 'the farmstead where barley is grown'.

Within the parish we find Middle Barton, a fifteenth-century name which began life as an outlying agricultural community; Seswell's Barton was formerly referred to as Barton Odonis and a reference to Odo who held lands here in 1210, later it became a part of the lands of William de Shareshull in 1335 and the basis for the modern name. Barton Grove, Great Barton and Little Grove have names which are all linked – 'the copse by Barton', the 'place called Barton which is bigger than Middle Barton', and 'the copse which is smaller than Barton Grove' repectively – each refers to the others and would be confusing if we did not know the order in which they appeared.

Daddles Close Spinney comes from 'Dadda's spring or stream'; Rayford Lane runs through 'the ford frequented by herons'; Showell Covert talks of 'the watercourse of the seven springs'; the Hoar Stone refers to a 'grey stone' which probably acted as a boundary marker; while Purgatory may seem to have sinister religious associations but in reality is just an insulting name for an agricultural project which was started but never completed.

Stoke Lyne

The Old English stoc, discussed in the following name, is here followed by the name of the landholder. William Lynde bought the estate in the fifteenth century, which means this is a comparatively late manorial addition.

Local names include Bainton, derived from 'Bada's farmstead'; Fewcot refers to 'few cottages' from feawe-cot; Devils Bit is a field name which would have been difficult to plough; quite the opposite to Dairy Ground where the pasture was excellent for grazing a dairy herd. Baynard's Green is a name always associated with horses, and here there is evidence to suggest that horse races were held here, with earlier tournaments during the reigns of Richard I (1189-99) and Henry III (1216-72).

Here the Peyton Arms recalls the name of a former tenant at Stoke Lyne.

Stoke Talmage

Found in 1086 as Stoches, in 1148 Stokes, in 1211 Stoke, and in 1220 as Stoke Talesmach, this name comes from the common element stoc or 'special place', yet only 'special' in the sense that it had a particular reason for being developed. With a common element, a second distinguishing part is to be expected. Here the name of Peter Thalemalche, who is recorded as granting land in 1148, would have given the family's name to the place.

Locally we find Gilton Hill takes its name from golde-dun, 'the golden hill' and a reference to the marigolds which would have grown there. Poppets Hill is from puca-pytt or 'goblin pit', a name which can be attributed to local folklore.

Stonesfield

A name which is not as it seems. Recorded as Stuntesfeld 1086, Stuntefelda 1130, Stontesfeld 1222, Stendesfeld 1230, Stutesfeld 1242, Sottefeld 1285, and Stonysfelde in 1526, this name comes from Old English for 'Stunt's open land'. This may read as a personal name, but is actually a nickname describing someone who should never have tried to start a farming settlement here.

Within the parish are a number of names of note. Callow Barn is named from 'the bare land'; Ruddy Well is from hryder wielle or 'the cattle stream'; Stockey Bottom and Stockey Plantation remembers the 'log enclosure'. The local here is the Black Head, a name of heraldic origin and probably showing the family concerned had ancestors who fought in the Crusades.

Stratton Audley

This parish has a name which comes from Old English straet-tun or 'the farmstead by a Roman road' which was associated with one William de Alditheleg in 1244, however he, or someone from his family, were probably here well before this.

Sutton Courtenay

First found in a record of 870 as Suthun, later we see Sudtone in 1086 and Suttone Curteney in 1284. As with many double-barrelled place names the addition is required to give a unique name. Often, as here, the name refers to the family who were lords of the manor – the Curtenai family were here in the twelfth century.

The local here is the Fish, the river being the obvious reference here and probably a sport loved by the original landlord or owner.

Swalciffe

Recorded in 1166 as Sualewclive, the name is Saxon in origin. From swealwe-clif, this speaks of '(the place at or near) the cliff frequented by swallows'.

Madmarston Hill seems to have no other etymology other than being a corruption of the neighbouring parish of Tadmarton.

Swerford

The ford in question crosses the River Swere, a name taken from the place. With records as Svrford in 1086, Swereford 1122, Sueresforde 1227, and in the modern from as early as 1230, this is from sweora-ford 'the river crossing by a gap in a ridge'.

Locally we find names such as Digger's Well from 'Dicen's spring'; Grunt Hole Furlong is an odd evolution from 'ground hole' literally a digging or pit; Lyons Spinney stood near ground which was among the land allowed to lie fallow, to allow the land the opportunity to be replenished with vital nutrients, and Master Lays Ditch has the same origin and refers to the channel dug to drain the area.

Swinbrook

Domesday tells us this place was known as Svinbroc in 1086. This Old English name is from swin-broc and speaks of 'the brook frequented by pigs'.

Locally we find Widford a name from the Old English withig - ford or 'ford by the willow trees'; it is related to Widley Copse 'the willow tree by the woodland clearing'. Faws Grove takes its name from faest-grafa 'the firm or dense grove' which probably is a reference to the tangled undergrowth rather than the trees themselves.

Swinford

The only early record of note is from 931 as Swynford, it comes from Old English swin-ford and is 'the ford frequented by pigs'. It is likely these were domesticated animals, regularly taken by the swineherd to take advantage of food sources on the other side of the river.

Swyncombe

In Domesday as Svincumbe, in 1219 as Suinescumb, in 1285 as Swenecumbe, and in 1397 as Souncoumbe this name tells us of 'the valley of the pigs', from Old English swin-cumb.

Cookley Farm here takes its name from the Old English for 'Cuca's woodland clearing'; Haycroft Wood is named from 'the field of hay near the woodland'; Flitwell Close is named from 'the field of the stream'; Prick Wood is a local term for the spindle tree; Quail Field is named because of the numbers of that species of bird to be consistently seen there. The names of Colliers Bottom, Colliersbottom Shaw, and Colliers Hill are too early to be from a miner and therefore must be a family name. Darkwood Farm is named because of the dense woodland; Vetch Close reminds us of the plant which grows in and around this field; Grandfathers Croft is probably not named from a specific grandfather, but a general reference to elderly gentlemen.

Sydenham

A name found as Sidreham in Domesday, Sidenham in 1216, and Sudenham in 1285 which comes from 'at the wide low-lying meadow'. This is a field name which here has grown to be a small settlement. Upcott Farm is located at the place where the first homes were referred to as 'the upper cottages'.

Here is a field name Cuckoo Pen which has the same origins as that of the Wise Men of Gotham. This collection of stories still has a message which could be heeded in the modern era. In respect to the story of the cuckoo, the men decided that by fencing in the tree on which the cuckoo sat, they could prevent the migration of the bird to warmer climes, thus halting the onset of winter. When completed the bird took one look at the fence and then the men, and promptly flew away. The men realised their stupidity and vowed that next year they would build the fence higher. It is likely that this enclosed field was sheltered enough to possibly attempt to grow more than one crop in a season, hence the name.

Chapter Eighteen

T

Tackley

Domesday's record of Tachelie is the only early listing of note. While this leaves the origin of the first element uncertain, the suffix is undoubtedly leah or 'woodland clearing'. Either this is a personal name and produces 'Taecca's leah', or from tacca which gives 'the clearing where sheep are reared'.

Within the parish we find Nethercott still seen to be 'the nether or lower cottage', while Weaveley Farm is from withig-leah which speaks of the 'willow wood' although, for some strange reason without distinction, there were actually two farms named Weaveley. Snakeshill Clump takes its name from Snokeshull meaning 'Snoc's hill'. Here is a personal name which has only ever been found recorded in place names which points to Snoc being a fantasy character. He was not a god nor a legendary man but probably a figure who lived underground, passing away the time by resculpting the face of the land. For all these places seem to be topographical features, odd lumps and bumps dotted indiscriminately in the landscape.

The name of Pound Hill would normally be thought of as being the village pound, where stray animals were held awaiting collection by the owner on payment of the statutory fine. However old forms reveal this first element as being from pawa which, although it speaks of 'peacock's hill' is more likely to be used here as a nickname than the bird itself. Sometimes it is necessary to examine the landscape itself to fathom the true meaning of Whitehill Farm. The farm is not on a hill but below it so wiht-hyll, literally 'bend hill', refers to 'the curved hollow of the hill'.

It is always a delight for the author to find a name with a narrative. Even better when the name exists solely because of the story, thus often making it unique. Such is the case with the Sturdy's Castle, where the sign shows two men engaged in deadly combat. The two men fought until it ended in the death of one. This did not end here, for the victor was tried and hanged for murder. The gallows were erected on the site where the pub now stands, the pub originally being called after the two men, Sturdy and Castle. Since the eighteenth century hanging the name has been altered to reflect local usage.

Tadmarton

Recorded as Tademaer tun in 956, Tademertun in 964, Tadmertun in 966, Thademertona in 1146, and Tademarton in 1180. It has been suggested that this name comes from Old English tademere-tun or 'the farmstead by the frog pool', however this is hardly a unique name and one which would only be applicable during the warmer seasons for these amphibians hibernate. Thus perhaps the true origin for the first element is gemaere or 'boundary', although it would not have been a particularly important point.

Taynton

Examining the early forms of Tengetune 1055, Teintuna 1059, Taengtune 1059, Tentone 1086, and as the modern spelling for the first time in 1675. The first element is an earlier name for Hazelford Brook, itself an example of back formation where the brook is named from the 'ford by the hazel trees' and which also gave its name to Hazelford Bridge. No records survive of the earlier name for the watercourse, however we can still define the name by association with other surviving names. This early name is related to that of the Teign in Devon, which comes from a British or Celtic word related to Welsh taen meaning 'a sprinkling' and one of the many stream names which simply suggest 'running water'.

Tetsworth

Recorded in 1150 as Testleswrthe we have an example of a Saxon personal name followed by the Old English worth. This gives the meaning as 'the enclosure of a man called Taetel'. Often the term 'enclosure' is understood to be a defensive fortification. However the combination of wooden pallisade, ditches and ramparts were more often designed to keep livestock safe inside.

Attington House takes its name from the minor place name which was here by the time of Domesday. It is recorded as Attendune in 1086, Etendon in 1166, Etingdon in 1275, Attyngdon in 1336, and Addington in 1797. This comes from Old English telling us of 'Eatta's hill'. Harlsford House and Harlsford Farm are recorded in 1822 as Earlsford Farm, however there is an earlier form dating from 1797 as Harlots Ford - so which is the correct? That there are no earlier forms and there is comparatively little time between the two records is telling. Here the earlier form, albeit an insult, is almost certainly the correct one and the early nineteenth-century record an attempt to hide the indescretions of the former owners.

Horsendon Hill may well be a transferred name from 'Horsa's hill' less than six miles distant in Berkshire. Latchfordhole Farm was the home of John Lacheford in 1300, he likely brought his name from 'the stream flowing through boggy land', a minor place name of Great Haseley. Another former villager gave his name to Judd's Lane, Richard Iudde being cited as owning land here and in Thame in 1300. Balsom and Balsam are two similar field names with a common origin, the term balsam was used to describe the yellow flowers of impatiens. Bandage Way is a description of how it wraps around the farmland, while the message conveyed in the description of Breakneck Hill requires no explanation.

Thame

A place recorded in 1000 and 1086 as Tame. It does not take much imagination to see this place takes its name from the River Thame, a Celtic or British river name which has identical origins to the Thames, itself discussed under its own entry.

Streets named after local families include Arnold Way, the Arnold family were long supporters and benefactors of local sport, providing land for the playing of football and hockey on which this street was cut. Berkeley Road is named after Sir John Berkeley, a Royalist army officer who has often been accused of being a double agent but this was probably suggested long after the conflict so as not to alienate one faction or the other. Sir Geoffrey Dormer, a woolstapler and merchant, gave his name to Dormer Road. Parliamentarian soldier Major General Charles Fleetwood provided the inspiration for Fleetwood Way. Lacey Drive is named after Samuel Lacey who served as Chairman of the Urban District Council and who gave the town hall its clock. W. B. Yeats lived here briefly, staying at Cuttlebrook House and giving his name to Yeats Close.

Thame Council Offices at Christmas.

Thame Park was the estate owned by the Bishop of Lincoln; the Great Dean field has nothing to do with religion, it is 'the larger valley field'; The Ham takes its name from a water meadow; Oat Plat was where that cereal grain was planted in 'the piece of ground for oats'; the Slinket is a dialect term for a narrow strip of ground; and Ware Meadow is a corrupted 'meadow by the weir'.

Here we find a number of interesting pub names, so called for a variety of reasons. The Abingdon Arms is named after the town; the Birdcage is one of a number of places referring to our feathered friends, so the cage is a simple image and gives distinction. The Falcon is rarely named directly after the bird or the ancient sport, more often it is an heraldic reference, found in a number of family crests – most notably those of Elizabeth I and William Shakespeare.

However the most interesting name is that of the Star & Garter. This refers to the Most Noble Order of the Garter, the highest order of knighthood in the land instituted by Edward III in 1348. Traditionally it was born at a court ball when the blue garter somehow slipped off the leg of the Countess of Salisbury. The king picked it up and was holding the familiar item in his hand when he noticed the whole room looking at him, a knowing look upon their faces. He slipped the item around his own leg and announced "Honi soit qui mal y pense" (evil to him who evil thinks). This became the motto of this exclusive order, limited to the reigining monarch and twenty-five others.

Thames, River

For the principal river wholly in England we should expect plenty of references in historical documents and indeed we find Tamesis in 51 BC. There are a number of river-names in England with the same root in the Celtic tongue: Thame, Tamar, Tame, Team, etc., all have a similarity which suggests a common origin. This name is understood to be either 'dark one', a reference to the colour of the river, or may simply be 'river'. If this sounds overly simplistic, consider that even today the local water course is rarely named but is simply 'the river'. In times when most people would probably never see another river in their entire lives, there would be no need to differentiate.

Thomley

Records of this name include Tumbeleia 1086, Thumeleya 1124, Thomeleya 1130, Thubely 1158, Tumelega 1163, Tomelee 1220, Tyuele 1285, and Thomle 1320. There are two schools of thought regarding the origin of this name, although the element is the same in both cases. Most explanations give this as a personal name followed by the common suffix leah and telling us this was 'Thuma's woodland clearing'. However the same word was also used as meaning 'dwarf', indeed it has the same etymology as the word 'thumb' describing it as a dwarf finger. The name of the place is the same, suggesting it is 'the woodland clearing of the little folk', any image from folklore or superstition such as dwarfs, fairies, etc.

Thrupp

This may seem an unusual name and yet it is quite commonly seen, either on its own or as the suffix thorpe. This is an Old English throp describing 'the outlying farmstead'. Standing alongside the canal here is the aptly named Boat Inn.

Tiddington

Records of this name are found from Domesday through to the modern day. Indeed there are more than enough to see this as 'Tytta's hill', the personal name seemingly a form of the more common Tutta.

Minor place names here include Albury, either 'the old fortified place' or possibly 'Ealda's fortified place'. Tadpole Copse is not a place riddled with the young of frogs, toads and newts, but a reference to its tadpole-like shape. Sixpenny Close is a field name which tells us of the rent charged for this place.

Toot Baldon

First recorded in 1086 as Baldendone it is seen with the addition in 1316 as Totbaldindon. The basic name comes from a Saxon personal name with the Old English dun, giving 'the hill of a man called Bealda'. In later years there was the addition of, not as normal a manorial reference, but the Old English tote or 'look-out hill'. This addition was to distinguish from Marsh Baldon, which lies less than a mile away and is listed under its own heading.

Field names here include Furzy Binchcroft, from 'the furze-covered field on a slope'; Flit Furlong comes from 'the land by the small stream'; The Lains tells this was land that was regularly allowed to lie fallow, an early indication of crop rotation in order to maximise production; and Works Bed Furlong comes from wergs or 'land of the willows'.

Mole Inn is a name which may have refer to a local field name, itself taken from a person living here who trapped these creatures for their fur. The image is easily recognised, despite few people ever having seen the animal, and makes an endearing and fairly unusual name.

Towersey

A place name which is recorded in Domesday simply as Eie becomes Turrisey by 1240. The eleventh-century listing is the Norman idea of what the Saxons would have written as eg. By the thirteenth century this description of the place also gave the the name of the family who held the place. Thus today's place name means 'the dry ground in wetland held by the de Turs family'. These people are recorded as being here by the thirteenth century.

From the days when the inn was a staging post for travellers, the equine equivalent of the modern service station. However in those days it was not tyres but horseshoes which needed attention, a service offered by the local blacksmith. In order to advertise the service, the pub would hang old horseshoes outside – also seen as a sign of good luck. The favourite number, perhaps because the ideal number would be four good shoes and suggesting a need for repair, is found here too in the Three Horseshoes.

Chapter Nineteen

U

Uffington

A name recorded in the tenth century as Uffentune and in Domesday as Offentone. Here the Old English tun follows a personal name, giving an origin of 'the farmstead of a man called Uffa'.

The Fox & Hounds name would have originally designated a place where the huntsmen gathered, either before or after the hunt. Today it is as often used as a standard pub name, especially in the light of the banning of hunting.

Uffington village and road signs.

Upper Heyford

'The ford used principally during hay making' is derived from the Old English heg-ford. Recorded as simply Hegford in 1086, the addition is distinguish from Lower Heyford less than a mile downstream from here. The local here is the Barley Mow, a common inn name derived from a mow or stack of barley, an indication of brewing.

Upton

A name recorded as Upeton in 1200, Huptone in 1214, and Opton in 1295 can still be seen as 'the higher farmstead'.

Within the parish are names such as Signet, listed as Senech, Seynat, Seynet, Seynate and Synett which has nothing to do with young water fowl but is from saenget or 'the place cleared by burning'. Battle Edge is traditionally said to be the site of the battle of Beorg feorda, fought in AD 752, and which refers to the battle fought at Burford while the name is a corruption of an unknown name.

White Horse Hill near Uffington.

Wayland's Smithy.

Chapter Twenty

V

Vale of the White Horse

A district name which is first seen in 1368 as The Vale of Whithors, the subject in question is a stylised figure of a white horse. Cut from the turf of the chalk hills the figure has been subjected to many dating techniques and, while the actual date of this figure was in question for some time, it is now known to date from the Bronze Age three thousand years ago. It is the only figure proven to be truly ancient, others may well prove to be simply copies.

Just what the builders intended the figure to say is widely disputed. Some maintain it was a tribal symbol connected to those who built Uffington Castle. However, if this was the case, why was the figure cut on a hill where there is no way of seeing the complete image unless one is airborne. This gives strength to the idea this can be considered religious or magical imagery.

Chapter Twenty-One

Wallingford

First seen in a document of 895 as Welingaforda, later as Walingford in 1086, this name comes from a Saxon personal name followed by inga-ford. This leads to a definition of 'the ford of the followers or family of a man called Wealh'.

Streets in and around Wallingford of interest include those developed by Crouch Ltd, who were responsible for the choices of the names of Brookmead Drive, Fraser Gardens, Hurst Close, and Aston Close in 1959, and in 1964 Hambledon Drive, Chiltern Crescent, Greenfield Crescent, Radnor Road, Marlow Close, and Allnatt Avenue. Cromwell Lodge was built in 1642, the year the English Civil War began and a good indication of where that family's loyalties lay. Thames Street has as obvious origins as Market Place, while Station Road did not exist before the arrival of the railway.

The name of Cavell is a famous one in Wallingford, and they are indeed related to Nurse Edith Cavell who was shot as a supposed spy by the Germans on 12th October 1915. Riverside was the residence of Percey de Mouchett Cavell JP, who served as mayor of the town in 1913/14.

Crispen Place was developed in late 1929, each house costing £440 to build. The council installed the wondrous new gas cookers, of course the tenants wanted their old ranges back as they were unhappy with the new technology. However just seven years later these same tenants approached the council to plead for removal of the gas lamps, to be replaced with new electric lights! The road was named from an old field name, where the owner penned his animals.

In 1867 four streets were renamed: Lock Lane, the site of an old turnpike, became Croft Road and named after a field nearby; Green Tree Lane, which tells its own origins, became New Road for obvious reasons; Fish Street, where the fish market was held, became St Mary's Street after the chapel; and Old Moor Lane, a former field name, became St Johns Road after the place or worship.

Saints names were also applied to roads which saw early attempts to ease traffic chaos, indeed much earlier than one would expect. A one-way system was in place up

St Martin's Street and down St Mary's Street from September 1933, following a similar restriction for St Leonard's Square in 1927, while the Lamb crossroads saw traffic lights for the first time in the late 1920s!

Here we find the Cross Keys, which is the symbol of Saint Peter to whom the nearby church is dedicated. Similarly the Green Tree takes adavantage of the local fauna. The Partridge is a name which may refer to the bird, in which case it is simply an easily recognised image, or more likely the name of a landlord or owner in the early days. The Dolphin probably comes from the name of a vessel, one with which an early occupant of the pub was associated, and King William IV would doubtless be proud of the number of pubs named in his honour.

Wallingford's town signs.

Wantage

A name which is recorded as Wanetinz in 1086, however it is the earlier record of Waneting from 880 which is the most helpful. From Old English wanian-ing, the name of Wantage means '(the place at) the fluctuating stream. Here is a description of a stream which was given to wild and rather sudden changes in strength and volume and, as such, must have been a constant threat to the settlement.

The Shears public house represents a trade, either the shearer or the shearman. Ostensibly the same tool is used by the shearer to clip the fleece from the sheep, the

The statue of Alfred the Great in Wantage.

shearman employed it to cut cloth. It was likely to be representative of the former trade of the landlord or owner. Another trade is commemorated by the Hatchet Inn, the tool which appears in the arms of the Foresters Company. Obviously the Lord Nelson is named England's greatest hero, yet few are aware that no individual has more pubs named after him than Admiral Horatio Nelson.

Six Bells on the Green, Warborough.

Warborough

In 1200 the name is recorded as Wardeberg, which comes from Old English weard-beorg. This name tells us this settlement began life as 'the watch or look-out hill'.

Field names such as Bomb Piece Furlong seem to tell of a turbulent history, especially when there is also a Boomb Piece, a Battle Hook, and a Battle Green. However there was no bomb but a 'broom', the hardy evergreen shrub with yellow flowers seen almost everywhere, while the 'battle' was land disputed by adjacent parishes or land holders. Similarly Boy Strert and Boy Veer would give 'Boia's tail of land' and 'Boia's weir' respectively, a personal name not a young man as the modern version would suggest.

Hudspud comes from 'Hudda's butts', a Middle English term for that uncultivated region at the edge of common land. Piss Furlong is the 'strip of land where peas were grown'; Shackles Piece tells us this was 'land covered by stubble', suggesting it was left after cutting for some time; Spiers Hill and Spiry Furlong are named for the 'tall coarse plants' which grew here; and the delightful sound of the field name of Tumbling

Bay tells us this was where part of the flow of the water in the river split off, possibly naturally, or created for irrigation or as an early flood channel.

The pub and the church, being the two public meeting places in a village, are very much linked. Here the Six Bells on the Green tells us the location on or by the village green, the link with the church, and the peal of six bells. A lot of information contained in just five very common words.

Cairn at Warborough commemorating the 4th World Ploughing Festival here in 1953.

Wardington

A name seen as Wardinton in 1180, Wardingtone in 1268, and Wordinton in 1268, which tell us this was once 'Wearda's farmstead'.

Bell Land was held by the Cropredy Bell Land Trust and a rent charged for the upkeep of the church clock and ringing of the bell, as instituted by the Reverend Roger Lupton of Cropredy following his death in 1512. Williamscot may still be recognisable as 'William's cottages' almost one thousand years after the name was first coined, but the pronunciation of "wilscot" is quite recent.

Water Eaton

For years the name of this place was simply Eaton. Derived from Old English ea-tun 'the farmstead by the river' the addition, to differentiate from nearby Woodeaton, is a second reference to the river and does not appear before the thirteenth century, some 500 years after the settlement is first recorded, as Eatun in 864.

Waterperry

Listed in Domesday as Perie, it later became Waterperi in 1190. The original name is derived from Old English pyrige with the later addition of waeter to distinguish from Woodperry, this gives us 'the place at the pear trees near the water'.

Minor names here include Clearsale, which began life as Cleihailesham in 1324, and describes the 'clayey water meadow of a man called Haegel'. Ledall Cottage has a basic name which comes from 'Leoda's corner of land'. Fatting Ground is a field name which speaks of where animals could find plenty of good grazing in order to put on weight. Little Lanket and Big Lanket are names which are derived from the term which speaks of 'a long narrow field', while the Whyrly is a field near to a river whirlpool.

Waterstock

A name recorded in 1086 as Stoch, in 1188 as Stoches, and in 1208 as Waterstokes. This comes from Old English stoc 'special place' and is prefixed by 'water'. As mentioned elsewhere in this book, that this place is 'special' should not be considered anything other than having a specific purpose. Here it is logical to assume the purpose was related to the water, possibly a place for fishing, trapping eels for example.

It may also be connected to another place name here, for Draycot tells us this was the draeg-cot 'the cottages by the portage'. In times before locks, a way had to be found to bring boats and the cargo past natural obstructions in the river. A small waterfall of a couple of inches, for example, might be just about navigable downstream but would prove an impassable barrier when travelling upstream. Hence the portage, a wet or muddy region alongside the obstruction where the boat and/or its cargo was dragged across the slippery land and the journey continued. This same system was also used for the loading and unloading of vessels.

Minor names here include Northam, 'the north water meadow'; Ling Croft is from 'the small field of flax', and the name was once shared by Lincrafte Bridge here; a water course which may well have been shared by the Werrea 'by the weir'.

Watlington

'The farmstead associated with a man called Waecel' is derived from a Saxon personal name followed by the elements ing-tun. This name is recorded as Waeclinctune in 887 and Watelintone 1086.

Couching Street has changed somewhat since the early days when it was 'the cooking street', where several traders sold cooked items and/or items for home baking. Gorville Street is a corrupted Goldwell Street referring, not to the precious metal but, to yellow flowering plants. High Street was not 'the most important street' before 1699, and Love Lane not much before 1800 and probably a family name, rather than anything amorous. How Hill is from hoh, and meaning 'the projecting ridge'. Launder's Farm comes from 'Lafa's slope', Seymour Green is a corrupted 'summer green', while Watcombe Manor took its name from the settlement which planted 'the wheat valley'. Dame Alice Farm is named after Alice of Cromwell, who held land around here and who also gave her name to Dame Alice's Lane and Damhales Farm.

Field names include the shapes resembling Little Anthill and Great Anthill, The name of Atmarsh comes from 'Haetta's marsh', Innings is always 'the land taken for cultivation', The Obelisk is actually cut into the chalk over the town, Pegs Ears was once 'Pecg's heath', Cowberry Lane does not describe a fruit but 'the lane where cows were buried', and similarly Fox Burys 'where fox bones were uncovered'.

Wendlebury

A name recorded as Wandesberie 1086, Wendelberi 1163, Wenlebur 1200, Wendelebur 1220, and Wendleburi 1232 which comes from 'Waendla's fortified place' with the suffix coming from burh.

Roman occupation is clear here in the name of Alchester, the suffix being Saxon ceaster 'Roman fortification'. The name is similar to Alcester in Warwickshire, and both stand on Roman roads with almost identical names in Buggildestret or Buggestret. Whether this is relevant when it comes to the name of these places is unknown. There seems no connection for the first element, Alcester is named after the River Alne, Alchester takes its first element from the Roman name for the place Alavna. This Roman name is suspected to have been the Latin version of an earlier British name, however the meaning of this is sadly unknown.

West Challow

The name comes from the Old English to describe 'the tumulus of a man called Ceawa', with the addition to distinguish it from East Challow which was undoubtedly named after the same person.

Westcote Barton

Recorded in 1050 as Baertune, in 1086 as Bertone, in 1221 as Parva Bartona, and in 1246 as Westcot, the addition is to differentiate from other Bartons nearby. Although in 1221 the addition told us this was the 'small Barton', the later name has prevailed. It is most likely that the two names were once quite distinctly separate, albeit not by much of a distance. Thus the bere-tun or 'farmstead where barley grows' had an area close by called west-cote or 'the west cottage(s)'.

Weston-on-the-Green

A name recorded in 1130 as Westona and which means what it says 'the western farmstead'. The addition, to differentiate from other similarly named places, is comparatively recent and simply alludes to the village green.

Minor names in the parish include Kemsley Barn, an obvious agricultural name which in turn came from a Saxon settlement known as 'Coenhelm's woodland clearing'. Sainthill Copse is a small area of woodland standing on a corrupted name from 'sandy hill'. Stonepit Hills refers to the many quarries which were dug in this region; Lady Grass Meadow reminds us of the striped ribbon grass, known locally as Lady grass or Lady's garters, which grew here.

The Ben Johnson public house is named after the poet and playwright (1572-1637). He was a great writer of the day and a friend of William Shakespeare who considered him the most influential writer of the period.

Westwell

A name recorded in Domesday as Westwelle and with similar spellings over the centuries. This name comes from the Old English west-wielle and telling of 'the spring or stream to the west'.

Wheatfield

Recorded as Witefelle in 1086, Withefeld in 1195, Hwytefeld in 1332, and Whitfeld in 1351, this name can be seen as coming from Old English hwit-feld and telling us this was 'the white field' and a reference to the chalk rather than any crop as the modern form of the name would suggest. Here we find Kiln Copse, wood being cut to produce charcoal and create a hot enough fire to smelt ore, while The Warren would have begun as a farmed area for rabbits as a food source.

Wheatley

The Old English hwaete-leah describes '(the place at) the woodland clearing is grown'. Wheatley was recorded as Hwatelega in 1663.

Local field names include Acre Mead, describing 'the acre meadow'; Chalgrove Field is named after 'the pit of the peasants' and a site of an important quarry of the day; Spioncop is a field name honouring the Battle of Spion Cop fought in the Boer Wars, when the British forces led by General Sir Redvers Buller were victorious; the Spurts is a common field name describing a place where a spring bubbles from the ground.

The Railway public house was named after the coming of the railway, a refreshment stop for those who had just arrived after their journey; the Kings Arms shows the pub was supportive of the monarchy, as does the House of Windsor; trees provided a seemingly permanent marker, such as that near the Maybush Inn; while a landmark

of the size of an Elm Tree would have been evident from a long distance; and the wool industry around the Cotswolds meant the Fleece would have plenty of potential customers to attract.

Whitchurch

Recorded in Hwitcyrcan in 990, Hwitcyrce in 1012, and Witecerce in 1086, this comes from the Old English literally meaning 'white church' but probably referring to a 'stone church' which would appear quite brilliantly white when compared to the more common wooden building. The addition of 'Hill' and 'Bridge' are of obvious meaning and are seen for Whitchurch Hill in 1254 and Whitchurch Bridge in 1806.

Binditch is a minor name derived from binnan and telling of a place 'within a ditch', and indeed is within the region of a large earthwork. Similarly Bozdean House and Bozdean Field have taken the name of another earthwork, however the etymology of this name has never been discovered. Walliscote House is thought to have been built by John Wallis, an Oxford professor who was here during the rule of Oliver Cromwell, Charles II and James II. A region which was used as common land was given the rather unusual name of Free Plats, the 'region ploughed and sown for a few months of the year and otherwise allowed to lie fallow' is the rather long description but simple concept conveyed by Great Hitch and Lower Hitch, and Winch Mead which is a pool alongside Winch Field and was where barges carrying essential supplies were winched by means of a long hawser across the natural obstruction known as Whitchurch Weir.

Whitchurch-upon-Thames

As with the previous entry 'a stone church' which would appear white when compared to a wooden construction, here standing on the famous river.

Wigginton

A fairly common place name, featuring a number of similar personal names. Here it is dervied from 'Wicga's farmstead'.

Windrush (River)

Recorded in 958 as waeric, in 1197 as Werich, in 1246 as Wenrhis, and in 1280 as Wenerishe, this name comes from an Old Celtic gwyn-reisko which would give 'happy fen'. Obviously this is not a good description of a river, however it is a fitting name for a 'pleasant river'.

Witney

A name recored as Wyttanige in 969 and Witenie in 1086, this comes from a Saxon personal name with the element eg. This gives us 'the dry ground in the marsh belonging to a man called Witta'.

The streets of Witney remember a number of its former important inhabitants. John Holford bequeathed a substantial sum of money to be invested for continued benefit to the poor and is marked by Holford Close. In 1916 three local dignitaries were working for the benefit of the place: J. Swingburn was churchwarden, E. Taphouse was a councillor, and E. Tarrant was not only a JP but also organist at St Mary's church. All three have streets named after them: Swingburn Place, Taphouse Avenue, and Tarrant Avenue repectively. Early Road remembers a family of blanket makers in Witney, while Vanner Road is named after a family who married into the Early line.

The House of Windsor, Witney.

Three ale houses of note here including the Robin Hood, one of the most common pub names which has grown along with the popularity of the folk hero. The earliest names are found in the nineteenth century when the reference was to the newly found Ancient Order of Foresters, a friendly society who held their courts or lodges at these establishments. As the legendary outlaw was a renowned benefactor it was almost inevtiable that these places would be known by its present name.

The Windrush is named after the river which passes through the town, yet the Rowing Machine has no water connection whatsoever. Witney has a long association with the

The Elm Tree, Witney.

production of blankets. In order to produce a more efficient product the pile was raised on the cloth after it was woven. This was achieved by an invention powered by a horse and known as a rowing machine.

Minor names in and around Witney include Cogges, from Middle English cog as in 'the cog of a wheel' and here used in the plural and referring to the hill. Langel Common is a name which comes from 'the long valley', Castle Yard is found alongside Cogges Church and which is held to be a former castle here, however there is no record of such and the most likely explanation is a personal name.

Wolvercote

Domesday's record of Ulfgarcote in 1086 tells us of 'the cottage associated with a man called Wulfgar'. The Saxon personal name is followed by ing-cot.

Local names include Blindwell Field and Blindwell Close, named after the 'blind spring' which was overgrown and difficult to find. Butts Furlong exhibits a Middle English term showing a strip of land, in this case a furlong or 220 years in length, which runs along or forms part of a boundary. Honey Cut Ditch is so named because of the sticky mud which it contains.

Woodeaton

Listed in Domesday as Etone the name came from ea-tun, the Old English 'farmstead by a river'. This is among the most common place names in the land, thus it should have been expected that an addition would be in place before long. Normally the addition would be a second name, however the wudu affix meaning 'wood' became the third element and is first seen in the listing as Wudeetun in 1185.

Field names here include Ackermans Meadow, not named after a person but 'the acre of the farmer'; Northam Meadow describes 'the north water meadow; while the names of Upper Ruworth and Lower Ruworth speaking of two fields known as 'the rye enclosure'.

Holy Rood Church, Woodeaton.

Woodcote

The record as Wdecote in 1109 almost seems an abbreviation. The name comes from the Old English wudu-cot or 'the cottages in or by the wood'.

Woodstock

Around 1000 AD the name is seen as Wudestoce while Domesday lists the name as Wodestoch. Old English wudu-stoc informs us this was 'the settlement in the woodland'. Blenheim Palace, one of the most famous stately homes in the country, is named after the Battle of Blenheim and given to the Duke of Marlborough for his part in the victory of 1704. Close examination of a map of the landscape of the gardens is recommended before looking at the gardens themselves, for the layout is based on the battle with trees planted to resemble the troops of both friend and foe.

Woodstock – the stone to mark the millennium.

Chaucer's Lane in Woodstock; once home to the poet, Geoffrey Chaucer.

The Star Inn is symbolic of the Worshipful Company of Innholders, although usually shown to be of religious origin. The Black Prince was Edward, Prince of Wales (1330-76) the eldest son of Edward III. An accomplished military man coupled with his humanitarian treatment of his enemies in victory made him a popular figure. There was a period of great mourning when he died of an illness at the age of 46. He was known as the Black Prince for the distinctive colour of his armour, however there is no real link between him and Woodstock and it seems unlikely to be the reason for the pub name. From 1650 the name was used for a succession of warships of the Royal Navy and it was likely a result of someone who served aboard one of these vessels.

Wootton

One of two such names places in the county, and many of this name elsewhere in England, this place is near Abingdon. Recorded as Wuttune in 985, it comes from the Old English wudu-tun and refers to 'the farmstead in or by a wood'.

Within the parish we find Upper and Lower Dornford Farms, both taking their name from the river crossing shared by both. From dierne-ford this is 'the hidden ford' and, as can be seen, there has been a change in the first vowel sound and comparatively recently around the eighteenth century. The river it crosses is also known as the Dorn, undoubtedly a case of back formation, the river named from the place, and thus one of the youngest river names in the land. The earlier name of the stream is not recorded, but perhaps Milford Bridge provides us with a clue. An early record gives the name as Meolcforda, which has been said to show the earlier name of the river to be the Meolc. This is not unheard of and as the water of this stream is sometimes decidedly 'milky', it seems we have found the earlier name of the river and its meaning.

The name of Hordley Farm is easier to understand when defined as being 'the treasure woodland clearing' from hord - leah. The farm is very close to Akeman Street and would refer to a horde buried during Roman times and discovered by the Saxons centuries ago. Another reference to the Roman road is Stratford Bridge the 'bridge of the ford on the Roman road'. Ludwell Farm is located on 'the stream named Hlyde', itself meaning 'loud', while the name of Woodleys comes from 'the woodland glade of the willow trees'.

Public houses are always keen to suggest something was going on within which would entertain, even if there was nothing more to be had than a drink. As such there was a wealth of names created and, among them, the Bystander Inn where you need not even take part, simply be a spectator.

Wootton

The second so-named place is near Woodstock, indeed it is sometimes referred to as Wootton-by-Woodstock. The name is identical in origin to the previous example meaning 'the farmstead in or by the wood'. It is recorded as Wudutune in 958, Wuttona in 1163, and Wotton in 1180.

Worton

Actually two places here, Nether Worton and Over Worton which first appear in the thirteenth century and suggest 'the upper and the lower', the basic name tells us of 'the farmstead by the bank or slope'. It is easy to see how the two places are located at the top and bottom of the slope which gives them their names.

Wroxton

A name found many times between Domesday and the end of the thirteenth century, indeed over this period there survives no less than 25 different versions, all but the earliest of these are dated from the last 100 years. This name means 'the buzzards' stone' from wrocca-stan.

Within the parish is found Balscott, listed as Berescote 1086, Belescot 1190, Balescot 1219, Belecot 1233, and Balscote 1242, this name speaks of 'Baell's cottages'. This personal name only ever appears in place names, but is also found here in Balscott Mill.

The pubs of Wroxton remember a local family in the North Arms and one of the county's most famous landmarks in the White Horse Inn.

Wychwood

This forest name is discussed under other entries, where it has become part of the place name. However it is a region and a place name in its own right and should be dealt with separately too. Listed as Huiccewudu in 840, as Hucheuuode in 1086, and Wichewude in 1185, this is the sole remaining clue in the county to the existence of the Hwicce, the tribe who dominated the region and including Gloucestershire, Worcestershire and Warwickshire by the seventh century. Thus the forest was known as 'the wudu of the Hwicce'.

Around this region we find Brasswell Corner and Brasswell Gate both come from 'Beorhtstan's nook of land'. Buckleap Copse and Sore Leap are derived from hliepgeat, a Saxon term for a leap gate, a lower part of a fence or hedge which could be jumped by deer but not by the domestic livestock. While the addition of 'buck' is an obvious reference to deer, that of sore will be less well known for it once described a buck of specifically four years of age and is now obsolete.

Within the general area of the woodland are place names which have been remembered in features such as fields, farms and copses. Cockshoothill Copse should be expected in extensive woodland. It refers to an old hunting method used for woodcock, woodland birds having excellent camouflage making them effectively invisible unless they move and having no smell so could not be detected by dogs. Hence beaters were employed to flush out the birds, forcing them to 'shoot' across the open glade in order to escape, only to become entangled in the waiting nets of the hunters.

Cranehill Copse takes the name of cran meaning 'the place near the hill where crane or heron are seen'. Dogslade Bottom has nothing to do with canines but is from docce-slaed or 'the valley of sorrel', a group of plants of which some were used in salads.

Evenden Copse takes its name from the Old English efen-denu or 'the level valley', while Fiveoak Copse may well have been composed of 'five oaks' standing out in the undergrowth. Lankridge Copse is found at the lang-hrycg or 'long ridge'; the naet-hrycg became Notteridge Copse or 'the wet ridge'; Slatepits Copse reminds us that the thinnest beds were extracted here for use as slates, flatstones known as Forest Marbles. Wastidge Spinney is a fairly late corruption, with the nineteenth-century record speaking of wastage and where there once was 'a waste land, a desolate area'.

Kingstanding Farm recalls the standing or hunter's station from which to shoot game, here as part of a royal hunting estate. Roustage is a place name from 'the dry grass not eaten by cattle' from a dialect word rouset with ecg or 'edge' and telling us this area had poor pasture and a dairy farm was not a viable undertaking; this was not the case with South Lawns from launde and giving an origin of 'the southern pastures'. Whitley Hill takes its name from the 'white or bright clearing'; while there is good reason to belive a corruption of the juniper berry has produced the rather unusual name of Jumpberry Corner. Broadquarter Allotments and Fair Spear are names describing the shape of the fields here. As a part of the Rogation ceremony known as 'beating the bounds', one of the pauses in the walk around the parish boundaries where prayers or scriptures were read is marked here by the name of the Gospel Oak.

Wytham

A name recorded as Wihtham in 957 and Winteham in 1086, it is derived from the Old English elements wiht-ham. From these terms we are able to define the name as 'the homestead in a river bend'.

Chapter Twenty-Two

Yarnton

Listed in 1005 as Aerdintune and in 1086 as Hardintone, this place name comes from a Saxon personal name followed by the Old English elements ing-tun. This gives a meaning of 'the farmstead associated with a man called Earda'.

With the parish boundaries are Paternoster Farm, which clearly stands on church land; West Mead, the meadow to the west of the village; and Frogwelldown Gorse and Frogwelldown Lane, names which speak of the crossing point of the spring or stream and nothing to do with amphibians.

The original turnpikes were a spiked barrier placed across a road for defensive purposes. In later years the name was given to the barrier to halt travellers until a toll had been paid to fund the upkeep of the roads. It was a natural progression to have such places become a stop when the stage coach was the main method of public transport. The Turnpike public house occupies one such site, part of a network of some 20,000 miles controlled by the Turnpike Trusts.

Common Place Name Elements

Element	Origin	Meaning
beau	Old French	fine, beautiful
beorg	Old English	hill
broc	Old English	brook, stream
burh	Old English	fortified place
burna	Old English	stream
caester	Old English	Roman stronghold
cirice	Old English	church
clif	Old English	cliff, slope, or bank
cnoll	Old English	hill-top
cot	Old English	cottage
cumb	Old English	valley (particularly a short valley)
dael	Old English	valley
denu	Old English	valley
dic	Old English	ditch
dun	Old English	hill
ea	Old English	river
eg	Old English	island, dry ground in marsh
feld	Old English	tract of land cleared of trees
fenn	Old English	marsh
ford	Old English	river-crossing
geat	Old English	gap, pass
halh	Old English	corner of land
ham	Old English	homestead
hamm	Old English	water meadow
holt	Old English	wood, thicket
hyll	Old English	hill
hyrst	Old English	wooded hill

Element	Origin	Meaning
inga	Old English	the family or the followers of
leah	Old English	woodland glade
port	Old English	market-place
stan	Old English	stone
stoc	Old English	secondary or special place
stow	Old English	assembly place
throp	Old English	hamlet
tun	Old English	farmstead, village
wald	Old English	high forest land
wella	Old English	spring, stream
wic	Old English	specialised farm (especially dairy)
worthig	Old English	enclosed settlement